IMAGES
of America

THE CINCINNATI
SUBWAY

HISTORY OF RAPID TRANSIT

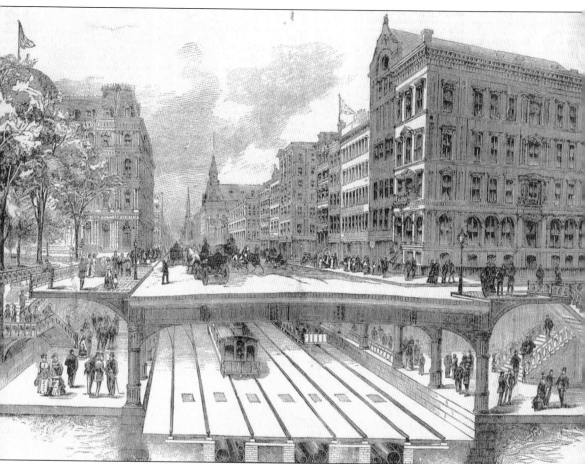

A local magazine, the *Graphic*, believed the Miami-Erie Canal could be drained and turned into subway and boulevard. This drawing, published in 1885, shows a subway scene that almost resembles Victorian London. It is a conceptual scene from 1880s New York City's *Broadway* showing what Cincinnati could look like if this really happened. (Courtesy the Mercantile Library.)

I believe a better study of this entire matter may be made after that bunch is out.

—Mayor Murray Seasongood on the Rapid Transit
Commissioners, December 22, 1927.

COVER PHOTOGRAPH: Subway construction in Section 2, just north of 12th Street (in what is now Central Parkway) on November 19, 1920, at 10:17 a.m. The completed tubes shown typify the construction taking place during an era in Cincinnati when the Queen City really thought rapid transit was the answer to current transportation and sociological problems. (Courtesy City of Cincinnati.)

IMAGES
of America

THE CINCINNATI
SUBWAY

HISTORY OF RAPID TRANSIT

Allen J. Singer

ARCADIA
PUBLISHING

Published by Arcadia Publishing
Charleston, South Carolina

Printed in the United States of America

Library of Congress Catalog Card Number: 2002117155

For all general information contact Arcadia Publishing at:
Telephone 843-853-2070
Fax 843-853-0044
E-mail sales@arcadiapublishing.com
For customer service and orders:
Toll-Free 1-888-313-2665

Visit us on the Internet at www.arcadiapublishing.com

Pictured above is an artist's depiction of a subway car leaving its platform and heading for Cincinnati.

CONTENTS

ACKNOWLEDGMENTS

This book encapsulates a year of research, writing, more research, more writing, and literally years of editing. I couldn't have written it at all without the patience of my loving and dedicated wife, Deanna, who allowed me to spend innumerable evenings and weekends writing and rewriting.

I thank my wife's grandparents, Don and Rose Linz, and her great-grandmother Minnie Linz, and her other late great-grandmother Mary Wernz and her late great-grandfather Stanley Wernz for all of their recollections of early days of Cincinnati history including the streetcars, the Depression, and World War II.

I also thank the nice folks at Cincinnati City Hall, including Structural Engineer Joseph Vogel, City Engineer Prem Garg, Engineer Steve Gressel, and Civil Engineer Technician John Luginbill. Thanks go to O. Henderson Jr., the City Municipal Library, the Cincinnati Public Library, the Mercantile Library, the Cincinnati Historical Society Library, the Greater Cincinnati/Northern Kentucky Film Commission, the Charter Committee, Dr. Peter Disimile of the University of Cincinnati, Attorney Thomas Brush, OKI Project Manager Warner Moore, OKI Planner Jeff Walker, David A. Etienne of Metro, and former Mayor Seasongood's own daughter, Janet Seasongood-Hoffheimer for lending me a photo of her father.

I am indebted to local interurban historian Earl Clark for all of his time, pictures, and information and friendship. Thanks also to all the Cincinnati Railbuffs, Bill Meyers, John H. White, Andrew Henderson, George Longfellow for designing and drawing the Cincinnati subway illustration, my father Paul, my mother Beverly, and my two sisters Beth and Julie.

Thanks also go out to my photographer Suzanne Fleming, who was such a terrific sport about taking her camera into the subway tunnels with me, and for taking even more pictures on a hot day in May.

Lastly I thank the people of Cincinnati for their continued interest in the failed subway. It's good that so many people retain an interest in a project that stopped over 70 years ago. It means that the dream of rapid transit has never died.

INTRODUCTION

The year was 1920 in downtown Cincinnati. The beginning of the Roaring Twenties was an exciting time for the Queen City: the war was over, the city was prospering, the people were happy and could afford to spend money. For only a dollar a week, a man could buy his fiancée a thirty dollar diamond engagement ring at Sterling Jewelry Company at 5 East Sixth Street, opposite the Palace Theater. Moviegoers flocked to see Cecil B. DeMille's new silent feature, *Male and Female*, playing at the Strand. And for twenty cents admission the Palace was presenting the play *Daddies*.

If a family wanted some home entertainment, they could buy a new Wurlitzer Kingston Player Piano for only $650 at the Rudolph Wurlitzer Company on East Fourth Street. Problems with cash? Pay "a small down payment, then easy monthly payments." Piano rolls cost fifty cents apiece at the Baldwin Company on West Fourth Street.

If a player piano was out of the price range, the Mabley and Carew Company ("Cincinnati's Greatest Store") sold nice living-room console Victrolas for $300. A table-top Victrola in an oak cabinet could be found at Wurlitzer's for $30.10. It came with six 10-inch double-face 78 RPM records of the customer's choice. Otherwise, popular new records cost eighty-five cents; some, a whole dollar at Mabley and Carew. Current popular hits were Al Jolson singing "I Gave Her That" and "Not in a Thousand Years" with Charles Harrison, both available on Columbia Records. Every family wanted a talking machine of their own and all the latest dance records to play on it. Innumerable record companies pressed thousands of discs; over a dozen versions of each popular tune were usually available.

In *The Cincinnati Post*, readers looked for "Freckles and his Friends" and "The Doings of the Duffs," popular comic strips in the newspaper. In the ad section, a new lady's dress cost $14.75 at Leon Marks Company on Fifth Street. A loaf of bread cost twelve cents and a gallon of milk was fifteen cents at Kroger's. Most people rode the streetcars downtown to shop, and always dressed up in their nicest clothes while visiting Shillito's and other department stores in the Queen City.

If a person needed to go shopping downtown, or visit nearly anywhere in the city, a ride on the streetcar cost a nickel. Streetcars crowded the downtown streets stopping only for passengers and the occasional automobile unlucky enough to crash into them. But something big was going to happen. The city was getting ready to start construction on the new subway system, one they hoped would alleviate traffic problems and create more downtown business. On Wednesday, January 28, 1920, they started digging.

Cincinnati thought it needed rapid transit during the early 1900s. At least, the city government certainly thought it was necessary. It was a great idea that could have worked, but who could have predicted the First World War breaking out? Who also could have predicted the popular use of a new invention, the automobile? Unfortunately for Cincinnati, the subway system turned out to be "the little engine that couldn't" and a great idea that was doomed from the start. The results of the subway project became a famous "white elephant."

The city of Cincinnati still has a subway system—sort of. The city today has the remnants

of a subway system that would never be completed. Two miles of a twin pair of subway tubes, station platforms, and even an unused *fallout shelter* exist under the city's streets, but most of the citizens don't know anything is there. Many people would be surprised to not only find out about them, but also to learn that the tubes are in fine condition, continuously maintained. Above ground, the tunnel exits—always covered and padlocked and rarely opened—stand beside a major interstate highway seen by thousands of people driving by every day. Most drivers don't know what the arched doors are, and would never suspect that they represent a failed rapid transit system from an earlier time in Cincinnati's history. This is a subway system that started its short life as an idea proposed by a city newspaper and ended as an expensive disappointment.

Many Cincinnatians today know a little about the subway, but nobody knows the whole story. Until now, the only ways to find out about the ill-fated attempt at rapid transit were to research old city reports at the library or to simply "ask around." People will talk about what they know about the history of the tubes and how big the subway loop was supposed to be. Some will even say that they have managed to enter the tunnels and see firsthand the surviving platforms and fallout shelter. Some of the older folks will tell how "everyone was excited about it" and really thought something was going to happen.

But what did happen? According to what is commonly known, the money ran out—but why? The Depression wouldn't start until 1929. Why was work suspended indefinitely in 1927? Why didn't later administrations restart the project?

Well, history has been made in Cincinnati, and now the entire story of why Cincinnati never got rapid transit finally can be told. And among the various rapid transit plans in every decade were different ideas of how to use the subway tunnels for everything *but* rapid transit. This is a chronicle covering over a century of hopes, dreams, money, trains, automobiles, corrupt politicians, not-so-corrupt politicians and lost visions of rapid transit in the Queen City of the West.

It is a story about a white elephant.

One

POLITICS OF
THE QUEEN CITY

In Cincinnati, 1884 was a year that its citizens would rather forget.

The 1880s was a rough decade for the Queen City. Drunken, raucous men and women who didn't fit into polite society filled the city's hundreds of beer halls night after night. Prostitution, gambling, murder, and mayhem were at all-time highs.

In December of 1883, William Kirk, a West End house trader and gambler, was beaten to death on Christmas Eve by his two helpers, William Berner and Joe Palmer, who wrapped his body in a sack and dumped it in the Mill Creek. The police soon caught them and put them downtown in the Hamilton County jail, which housed 40 killers by March.

Cincinnati's police force at the time consisted of 300 men and 5 patrol wagons. They apprehended 50 murderers in the period; only 4 were sentenced to hang. The March 9, 1884 edition of *The Cincinnati Enquirer* reported that in the past decade, "over eight hundred arrests have been made of men who, with knives, pistols, or other deadly weapons, have, with more or less success, attempted the lives of fellow creatures." The *Enquirer* stated that the Queen City's pre-eminence in art, science and industry amounted to nothing when "murder is rampant and the lives of citizens are unsafe even in broad daylight Laxity of laws has given the Queen City of the West its crimson record."

When William Berner soon stood trial, the State asked for the death penalty, but the jury reduced the verdict to "guilty of manslaughter." The *Enquirer* reported, "Never was there a verdict in a criminal case that caused as much open and unfavorable comment as that of the jury yesterday. . . ." On March 27, Judge Matthews gave Berner the maximum sentence for manslaughter: 20 years in the penitentiary. After hearing the verdict, the people of Cincinnati decided they had had enough.

At Music Hall that Friday evening, prominent citizens called a town meeting to protest the jury process. They hoped to start a reform movement to put an end to what the public saw as continuous miscarriages of justice. Eight thousand citizens crammed into the public house, with thousands more standing outside. Many people brought ropes, thinking it was a vigilante committee. Inside, opinions were thrown and debated, and many tempers flared. Before the meeting closed, everyone was asked to return home quietly.

After the meeting adjourned, however, a man's voice bellowed above the thousands of voices, "On to the jail! Follow me! Let's hang Berner!" The angry people moved out of the hall and down the street, many shouting, "Give us Berner!"

The mob pushed its way to Sycamore Street to the front of the jailhouse where people threw sticks, stones, bricks and other objects against the walls. A small group battered against the front door with a wooden beam. The door crashed open and hundreds of men swarmed into the inner offices screaming for Berner. Sheriff Hawkins and his men quieted the crowd and told them that Berner had already been taken to the penitentiary. The Sheriff and his officers forced the mob back outside, where someone in the crowd fired a gun several times and killed a man. Meanwhile, the state militia arrived and started firing their guns, killing several bystanders. A hundred policemen and a couple hundred soldiers defended the courthouse, and by 3:00 a.m., 5 people were dead and 50 were wounded.

Armed citizens congregated back at the courthouse on Saturday until thousands jammed the streets. That afternoon the tension finally broke and the mob charged the barricades, both sides exchanging

gunfire for several hours. The wounded were taken to Burdsal's Drugstore, nearby saloons, and City Hospital. The dead were taken to Habig's morgue on Sixth Street.

As the sun rose that Sunday morning, statewide Ohio militia guarded Courthouse Square. Crowds gathered at the scene of the previous day's battles, but the fight had gone out of them. Few could forget the gruesome images from Saturday: wounded men lying on the floor of the drugstore, dead neighbors in Habig's morgue, horse-drawn ambulances rushing casualties to the hospital hour after hour. One more attack was advanced that evening on the courthouse, and Gatling guns started firing again. Several civilians fell, some mortally injured; many others ran away. After the guns stopped firing, the remainders of the crowd went home; the battle was over.

Later in 1884 the public learned that 56 persons had been killed and more than 300 men and boys were wounded during that terrible weekend.

The Courthouse Riots symbolized what was wrong with Cincinnati during the late 1800s. A weak government, run by the Democratic Party, literally ran the city into the ground, and what resulted was lawlessness and social disorder. During these latter decades, downtown residents and suburban dwellers argued and fought with each other, the fire department expanded very little, small water mains inadequately supplied the upper West End, a six million dollar water plant project was voted down causing a weak and contaminated water supply, and several suburbs were practically without sewers. City departments suffered under the weak leadership, including the health department and city hospital and city workhouse. Even the school system struggled under urban expansion, population growth, and deterioration of old facilities.

The bleak problems that plagued the city immortalized the ineffective methods by which the Democrat-controlled City Hall governed. Newspaper muckraking soon caused a party overturn and the Democrats were ousted from power. The Republican Party marched triumphantly into office, promising a new future.

A new future was definitely what Cincinnati needed at this point, especially after the social outrage that led to the Courthouse Riots and continued afterwards. The city needed a new executive, one who could make decisions and bring progress to the city. Cincinnati got its executive all right, in the form of a political boss in charge of the Republican Machine that would carry the city into the 20th Century: George Barnsdale Cox, a.k.a. "Boss Cox."

One early and important development that the Cox organization instituted was the incorporation of suburbs and villages which were located within the city limits, but were not an actual part of the city. These suburbs lacked water, sewerage, and other utilities that the city could provide. In some cases, village government was so inept that the majority of residents wanted to annex. The passage of the Lillard Law in 1893 made the expansion possible for cities throughout Ohio, and help increase the size and status of Cincinnati.

Two local industrial villages resisted, and only later changes in the law allowed St. Bernard and Norwood to avoid annexation by becoming cities themselves. Cincinnati, then, merely expanded around these two exceptions. The rapid transit system yet to come would actually have to negotiate its way through St. Bernard and Norwood.

In 1905 Cox declared himself "Boss of Cincinnati." He saw himself as a great benefactor for Cincinnati and declared, "I've got the best system of government in this country. If I didn't think my system was the best I would consider that I was a failure in life." But during his reign, Cincinnati held the reputation as "the worst governed city in the United States." Bonds were issued indiscriminately which caused the squandering of huge sums of money funded by the taxpayers.

Cox isn't remembered only for his corrupt politics. Certainly graft and favors abounded and poor construction work sometimes resulted, but at the same time Cox did accomplish positive improvements for the city. City officeholders and administrators improved police and fire departments, paved hundreds of miles of city streets, built sewer lines, created the Water Works, tried to reduce the smoke problem in the Basin and continually kept taxes low. (Although it should be pointed out that the quality of work wasn't always good.) And most importantly, Cox and his organization provided a center that was strong and long-lasting enough to hold the city together through a turbulent period of rapid change and growth.

Gradually Cincinnati grew and matured into the twentieth century leaving the turbulence of the 1880s behind. As a result, Cox could not continue as the boss of his machine. As the city continued annexing surrounding suburbs, thousands of new middle-class voters thought Cox was an embarrassing relic with outdated methods.

Reformers tried to clean up the city for most of the 30 years Cox was in power. In fact, during the first 15 years of the new century, citizen groups had exposed corruption, election frauds, and scandals in the

Republican ranks. The Cox Gang had undergone several of these investigations over the years, but Cox had always survived.

In 1911 the Democrats chose County Prosecuter Henry Hunt to run for mayor. Hunt campaigned against what he called the "criminal classes and the so-called Republican organization." He attacked the Grand Old Party and promised action on the city's many problems with an honest administration. Hunt and his running mates were elected, and Cox and his gang stood in the wings waiting for their comeback.

Hunt believed professionals should run the city departments just as trained and knowledgeable people ran corporations. He wanted to make Cincinnati a great city, and proposed tax increases for new programs. He developed scientific budget-making and showed the public the expenditures of all departments and the services they provided. He also persuaded the voters to pass a tax levy for expanding city services.

In his short tenure, Mayor Hunt organized a Bureau of Social Investigation, cleaned up the House of Refuge, cleared the shantytown from the shores of the Mill Creek, closed about sixty local dives and spearheaded a citywide plan for rapid transit.

Mayor Hunt was defeated in the 1913 election. Unfortunately for him, he discovered that it would be too costly to completely clean up the city and undertake the major improvements needed. Cincinnati favored low taxes more than modern government, so Hunt failed to carry through with his programs and left the city after his defeat. Republicans returned to power in 1913, only to struggle on for a dozen more years under the weakened leadership of Cox's old henchmen. In 1915 Boss Cox retired from politics and died of a stroke on May 20th of the following year, at age 63.

A decade later, Cincinnati would witness sweeping changes in city government with the "Charter Movement." The "Charterites" proposed a new city charter that called for a professionally-trained City Manager rather than elected politicians. They also presented a plan to reduce the 32 member council to a council of 9 members elected at large. The man who pushed the amendments through City Hall and debated with the current members of City Council was a lawyer and Charterite named Murray Seasongood.

The Charter amendments were passed with the overwhelming count of 92,510 to 41,015 in the 1924 City Charter campaign. Later, in the 1925 City Councilman campaign, Murray Seasongood was elected with five other Charterites. When the new City Council met on January 1, 1926, they chose Murray Seasongood as mayor.

The old Republican machine had been totally annihilated. The new mayor hired Colonel Clarence Sherrill, superintendent of parks and public buildings in Washington, D.C., as the city manager. Almost 4000 city employees suddenly found themselves on "civil service," no longer beholden to any politician for their jobs.

Financially, the city became the soundest in the nation. The city's parks and playgrounds nearly doubled in number. The cost of gas to consumers was reduced by half a million dollars yearly. Child health services and free clinics were created, and a new food-permit plan was set up to control restaurants, markets, and milk handlers. Fifteen new public schools were built after 1925, and eight additions were joined to older buildings.

Cincinnati went through some major changes during the early twentieth century, and it was within the turbulent environment that the stage was set for the failed rapid transit plan. The project really belonged to the city government in which Mayor Hunt unwittingly found himself, and by the time Mayor Seasongood took office, the project had ended. His city did not need rapid transit anymore and he had no intention of continuing the project.

It is important to understand the political structure of the city of Cincinnati during the early twentieth century to have an idea of why the rapid transit plan failed. In the midst of all of the dirty politics going on in the Queen City, the plan came to life; and like every plan, political or otherwise, this one started with a dream. Although 1884 was a bad year for Cincinnati, some good came of it because the dawn of the subway dream began that same year—as a simple drawing.

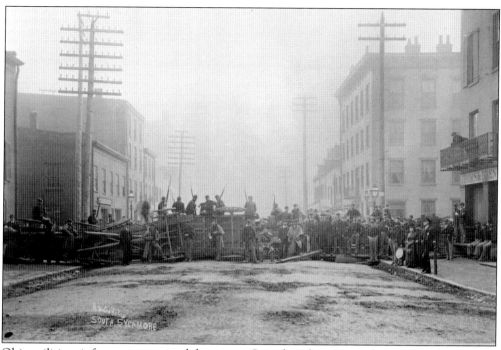

Ohio militia reinforcements arrived downtown Saturday afternoon and set up barricades of barrels, tables, wagons, and mattresses. (Courtesy the Cincinnati Historical Society Library.)

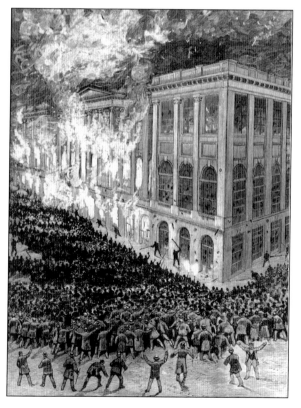

At dusk, over two hundred men broke through the lines and into the courthouse. Inside they piled up furniture, set it on fire and poured kerosene on the flames. On the street, the mob prevented firefighters from laying down hose and pumping water. Soon an inferno engulfed the courthouse, and it burned to the ground, leaving only a smoking pile of ruins. (courtesy the Cincinnati Historical Society Library)

Newspaper headlines in the days following the riots. (Used with permission from *The Cincinnati Enquirer*.)

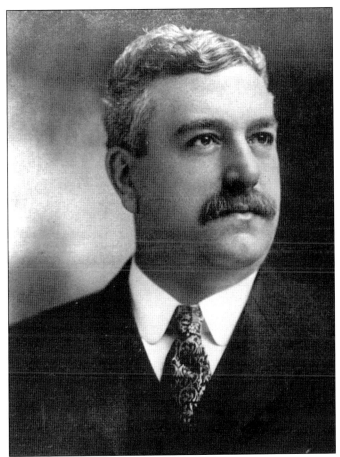

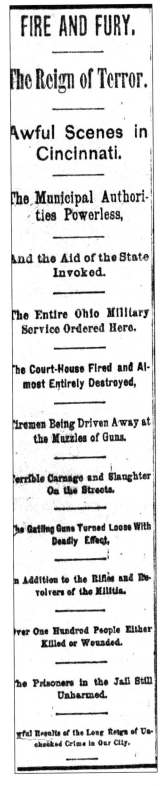

As a young man, George Cox owned the Mecca saloon and voted Republican and, because the city was under Democratic control, he found his saloon enduring continuous police harassment. In 1879, he decided to run for City Council, hoping to become immune to attack. He began his career in politics without any ambition of becoming a boss, and ran Cincinnati behind the scenes as a political organizer. Among his other office duties, he would hear grievances and review job applicants amid the bustle of his Mecca saloon during the day, and retire for the evening with his henchmen at Wielert's Garden in Over-the-Rhine at night. While the city leaders continually would remind the public of the city's low taxes, low quality street-paving jobs were being performed, the wattage of street lights was reduced, and the needs of the schools and the health department were neglected—all of which occurred throughout the 1910s. Cox then boasted that he had taken the schools, fire and police departments out of politics. (Courtesy the Cincinnati Historical Society Library.)

FIRE AND FURY.

The Reign of Terror.

Awful Scenes in Cincinnati.

The Municipal Authorities Powerless,

And the Aid of the State Invoked.

The Entire Ohio Military Service Ordered Here.

The Court-House Fired and Almost Entirely Destroyed,

Firemen Being Driven Away at the Muzzles of Guns.

Terrible Carnage and Slaughter On the Streets.

The Gatling Guns Turned Loose With Deadly Effect,

In Addition to the Rifles and Revolvers of the Militia.

Over One Hundred People Either Killed or Wounded.

The Prisoners in the Jail Still Unharmed.

Awful Results of the Long Reign of Unchecked Crime in Our City.

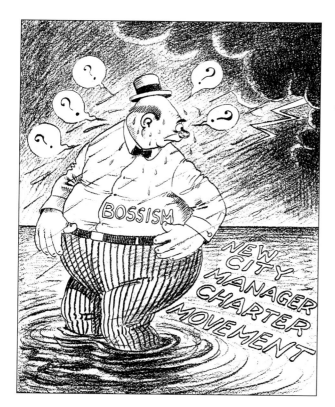

Anti-bossism cartoons appeared in local papers. The Charterite Party was moving in, signaling changes in city government. (Courtesy the Charter Committee of Greater Cincinnati.)

Cox's protégé, Rudulph Hynicka, controlled Cox's former interests, but spent most of his time in New York, keeping in touch with his cohorts by telephone and telegraph. Several important issues are mentioned here: the Upson Report, bond issues, and the City Manager Charter. The Upson Committee investigated city government in 1924. The Upson Report revealed that a completed rapid transit system would cost much more than estimated, and would not be profitable due to the fact that interurbans were going out of business at that time. (Courtesy the Charter Committee of Greater Cincinnati.)

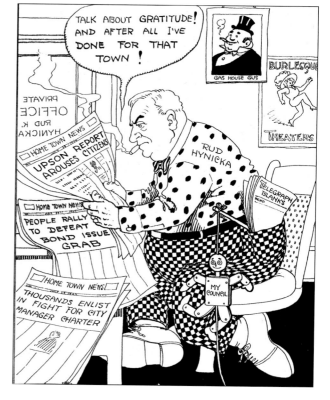

The subway bond, fair elections, and rising car fares are all hot topics during the Boss era. The "City Hole Administration" is an obvious attack on the boss-run City Hall. The "hole" refers to the potholes that plagued city streets resulting from poor maintenance. (Courtesy the Charter Committee of Greater Cincinnati.)

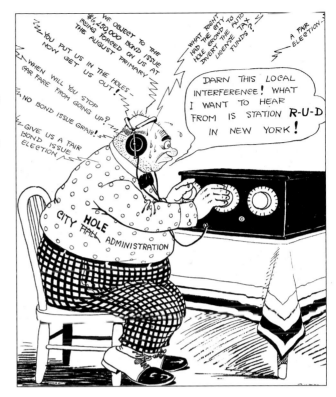

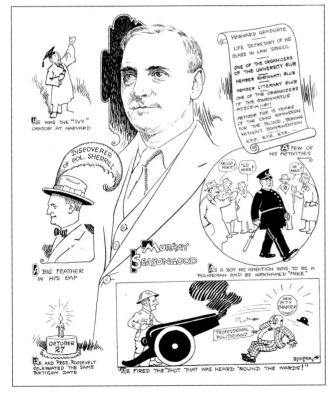

The leftover Cox gang was no match for Murray Seasongood's verbal firepower, and he would consistently win political debates. (In one debate, Seasongood was said to have "fired the shot heard around the [voting] wards.") He pushed for reforming the city's problems and concluded, "It is a crime what the people of Cincinnati are undergoing, not only in the matter of receiving nothing for their money, but in being drugged into a state of political lethargy that is fast making the city a laughingstock." (Courtesy the Charter Committee of Greater Cincinnati.)

Fame had found Seasongood by the time he summed up his and the first City Manager's accomplishments: "Cincinnati has been transformed from a rundown, shabby, despairing boss-ridden city to a forward-looking, confident, clean, and well-conducted municipal corporation, governed by citizens with expert assistance." He remained mayor through 1930. (Courtesy Janet Seasongood-Hoffheimer, through the Charter Committee of Greater Cincinnati.)

Two

THE DREAM
OF THE GRAPHIC

In the nineteenth century, the industrial river town of Cincinnati, Ohio, was called the "Queen City of the West" and "Porkopolis" (the latter for its pork-packing industry through the 1800s). By the turn of the twentieth century the city thrived as a leading trade center and one of the ten largest cities in America. Cincinnati's fast growth is mostly attributed to the water transport along the Ohio River and the Miami-Erie Canal. This canal provided Cincinnati and other large and small towns inside of Ohio access to both the Ohio River and Lake Erie. Consequently, the towns could easily trade with the markets on the East Coast.

Between 1825 and 1856, the Miami-Erie Canal offered cheap, reliable transport of goods and passengers; and with the Ohio River, helped the Midwest grow. Industrial progress, however, made the canal obsolete with the growth of steam railroads and the interurban electric railroad service. The interurbans, or "traction lines," helped develop Cincinnati and other Midwestern cities; they ran all over the Midwest transporting passengers and goods at high rates of speed. These heavy, new electric trains powered by overhead wires connected the small towns to the big cities just as the canal did a few years before, only the trips could take mere hours instead of days, often in luxurious comfort.

Nine traction lines operated out of Cincinnati. They were controlled by seven different companies and extended in nine different directions to surrounding cities and towns:

• The Millcreek Valley Lines, which was operated by various companies including the Cincinnati Street Railway company, from 1864 to 1932, serving Carthage, Lockland, Glendale and Hamilton.

• CG&P: the Cincinnati, Georgetown, and Portsmouth, which ran from 1873 to 1935 and served areas east of the city including Mt. Carmel, Bethel, Georgetown, and Russellville.

• C&LE: the Cincinnati and Lake Erie, which operated from 1898 to 1939 and connected Cincinnati with Dayton, Columbus, Toledo, and Detroit.

• CL&A: the Cincinnati, Lawrenceburg (Indiana) and Aurora (Indiana), which operated from 1900 to 1930 linking Cincinnati to Southeastern Indiana.

• IR&T: the Interurban Railway and Terminal, which operated from 1903 to 1922 serving points east including Batavia, New Richmond, and Bethel.

• CM&L: the Cincinnati, Milford and Loveland, which operated from 1904 to 1926, when it was taken over by the Cincinnati Street Railway Company, served Mariemont, Indian Hill and Terrace Park. The CM&L eventually became the CM&B to include Blanchester.

• C&C: the Cincinnati and Columbus, which operated from 1905 to 1919, and served Norwood and Hillsboro.

Steam railroads, meanwhile, dominated high-speed interstate freight and passenger service. The railroads began development in the 1850s and also helped drive the canal out of business. Cincinnati then began to rely on steam trains to convey raw materials to its factories and to export finished products to other cities in the country. The trains of seven rail companies chugged through Ohio: the Baltimore & Ohio, Chesapeake & Ohio, Louisville & Nashville, New York Central, Norfolk & Western, Pennsylvania, and the Cincinnati Southern Railway. The last was the property of the city and was leased to the great Southern Railway system.

The extensive service of the traction lines, which offered transport for both freight and human cargo, made usage of the canal unprofitable by 1856. In 1877 the city officially abandoned the canal, and by 1884

its former glory was a tarnished entity, called by a local magazine a "foully-smelling and miasma-breeding" cesspool. The slow moving water became stagnant during the hot Cincinnati summers. Dead animals and waste from the hundreds of buildings that lined the canal polluted the water. The decomposing corpses of the animals released noxious gasses and created the general atmosphere of miasma. In some locations around the city, the canal was a serious health hazard.

But still, the canal remained a relatively inexpensive and effective way to transport bulk cargoes such as gravel, lumber and agricultural products across town. Its only other use was found by many Cincinnati children and adults who occasionally would play in the murky waters, using it as a swimming hole in the summer and skating rink in the winter. Otherwise, the canal sat unused for interstate commerce, continuing to be a health hazard. So far, no move had been made to remove it.

The September 27, 1884 issue of the Cincinnati weekly magazine, the *Graphic*, stated, "The changes which time brings in all things cause many heartaches, but the heartaches of those who cling so fondly to the dead old ditch can in no degree compensate for the malarial headaches of hundreds who must suffer from its influences." The *Graphic* knew how to utilize the canal. Turn the ditch into a subterranean rapid-transit system. On the cover of that September issue it portrayed a prophetic cartoon of a steam-powered train driving out of a subway tunnel under the city streets. Above the tunnel's egress the artist pictured a new roadway taking the place of the obsolete canal. The drawing was called "The Dream of the *Graphic*" and would have a profound impact on the city government. "It is but a dream of the *Graphic* put in black and white . . . but it tells its own story," stated the magazine. "Will it ever be fulfilled?"

The most popular question at this time was whether Cincinnati would benefit from a rapid transit system. The city already had a successful streetcar system, but streetcars were anything but rapid.

Downtown Cincinnati had many traffic problems, and the streetcar was at the heart. But years before electric streetcars prowled the downtown streets, as early as the 1850s, the Queen City had already begun to grow too large for casual walking from home to work. To combat this problem, City Council called for the development of street railroads—"horsecar" lines—to replace omnibuses. Omnibuses were independently-owned covered passenger wagons pulled by horses along the downtown streets.

A major problem with omnibuses was that not only did they cost a dime to ride, which was quite a bit of cash back then, but they often had trouble navigating through the streets after a heavy rain fall. Omnibuses normally offered bumpy and uncomfortable rides, but when pulled through muddy streets full of long ruts the ride could be treacherous and even dangerous. Progress clearly was needed.

Cincinnati installed inclined plane railways to quickly and easily climb the daunting hills. Five major hilltops in Cincinnati were served by inclines: Mt. Auburn, Price Hill, Fairview, Clifton Heights, and Mt. Adams. These hilltops contained the suburbs commanding magnificent views of the Queen City. Riders could escape the polluted air of the downtown district for the clean skies of the hilltops. Lines formed every hour with people waiting to ride the inclines up the hills to enjoy a beer at a saloon while taking in the view of the city.

For over two decades, the inclined planes were recognized as sociological icons within Cincinnati and symbolized technological achievement for the city. In retrospect, they could even be called a very early attempt at mass transit with a near-perfect safety record. The first to be built ran from Main Street up Jackson Hill to Mt. Auburn. It was the scene of the city's only fatal incline accident. On October 15, 1889, a steam valve stuck open and could not stop the engines, and a car crashed to the bottom of the hill, killing six passengers and critically injuring one. Both defective machinery and a careless operator were blamed for the accident.

The inclines served their purpose well; too well, perhaps, for the very suburbs that they helped create soon brought a demand for faster methods to transport the increasing population. More efficient cable cars would take the place of inclines, and all but the Mt. Adams Incline were dismantled one-by-one through the first half of the 1900s. That remaining incline continued its operation for over seventy years, until 1948.

Steam powered streetcars, or "steam dummies," briefly augmented horsecars. Cable cars also were built to carry passengers up the hills. A few restaurants, theaters, taverns, and stores blossomed along major steam dummy and cable car routes, routes that existed mainly in the East End to Columbia and Mt. Lookout until the 1890s. Three cable car companies formed: Mt. Auburn Cable Railway, Walnut Hills, and Vine Street; and their operations lasted only from 1885 to 1902. At this time, Thomas Edison's DC, direct current electricity was generating interest around Cincinnati as well as the rest of the country.

In June 1888, the Street Railway Company began converting to DC to power their new streetcars and fully remove horses from the system. The electric streetcars, or "trolleys" (a trolley was actually the rooftop pole that connected the streetcar to the overhead power lines), replaced horsecars, steam dummies and cable cars. With the new faster, quieter, safer, and much cheaper electric streetcars, along with industrial development, the Mill Creek Valley and other surrounding communities exploded with growth. Working

class citizens now could travel easily from downtown jobs to their homes outside the Basin.

By 1910, 222 miles of streetcar tracks wound their way through the crowded streets of Cincinnati. For every thousand of the 386,000 inhabitants there was an average of a half-mile of single track. The streetcars existed as Cincinnati's main form of public transportation at the time (privately-owned city buses started running in 1913). Although they were faster than horsecars, they still were relatively slow and often packed with passengers jammed inside, hanging on the edges, and sitting on the roofs, resulting in many confrontations and fistfights in the tight quarters. Streetcar travel was slow because the trolleys had to follow traffic laws and stop at intersections and lights and slow down for other traffic.

Not only did the streetcar shuttle citizens around the city, but hundreds of Model Ts and flivvers and even horse drawn carriages continued to congest the streets as well. In the early twentieth century, the automobile was an appealing invention that many Cincinnatians owned thanks to the assembly lines of Henry Ford, but were still not used to driving, especially after growing up and riding on public transportation. Although traffic laws were still nonexistent at this time, city ordinances passed in 1903 set speed limits of 7 miles-per-hour in downtown and 15 in outlying areas. No one under age 16 was allowed to drive, and horse-drawn vehicles were to be given the right-of-way.

Automobiles and streetcars together sometimes created problems for pedestrians. Impatient motorists occasionally would drive between a streetcar and its passenger-loading platform and accidentally run over someone stepping off the platform to board the streetcar. Automobiles almost daily collided with streetcars, and even sometimes at night, despite both having lights. Cincinnati was caught in the middle of a major traffic nightmare that could only get worse. Rapid transit still was just a dream, but one whose realization could offer a solution to traffic concerns.

The Miami-Erie Canal needed to be dealt with; and a boulevard was something the city needed, more than it needed the canal. In 1907, the *Report of the Park Commissioners* was presented to City Hall. This report, called the "Kessler Plan," after George Kessler, the Kansas City landscape architect who developed it, detailed the plans for a citywide system of parks, public squares, playgrounds, and connecting roadways.

The "Kessler Plan" called for a wide road along the route of the canal that would help city development by providing "a wide passage into the very heart of the business district." The new road would also serve the entire Mill Creek Valley and the communities on the surrounding hills. This road was Central Parkway, planned to be a "grand boulevard," 150 feet wide with a road "on each side of a continuous central park space" that would be decorated with fountains, gardens, walks, and benches. In other words, it was to be a wide, scenic, inner-city park/boulevard.

And underneath Central Parkway? Just three years later Cincinnati's new mayor would propose that instead of filling in the canal with tons of dirt, an underground transit system could be built in its hollow bed.

The dying canal was hoped to be resurrected as a new subway system.

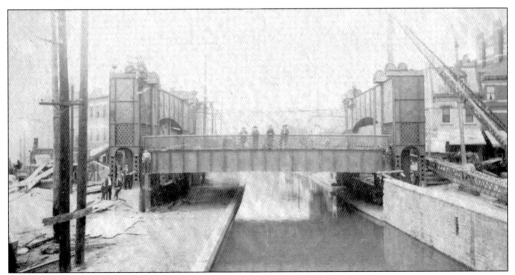

This bridge spanned the canal at Mohawk in 1911, and could be raised to let canal boats pass through (note the towpath on the left). The bridge got stuck in the up position more than once. (Courtesy City of Cincinnati.)

ARTICLES OF AGREEMENT, made and concluded this *fifth* day of *June* in the year *1826* between *David Considine, Cornelius Ryan, Reynard Dougherty, and Michael Murphy*

[the remainder of this dense contract facsimile is largely illegible]

This copy of the original contract called for building Section 91 of the Miami-Erie Canal, dated June 5, 1826. (Courtesy City of Cincinnati.)

In 1815 a 66 mile route for the Miami-Erie Canal was marked out and surveyed to span from Cincinnati to Dayton. The canal would branch off of the Ohio River, wind through downtown and continue north through the hills via the suburbs of Northside, Clifton, St. Bernard, Elmwood Place, and out of the city. Groundbreaking took place in Middletown, Ohio, on July 21, 1825. The Miami-Erie Canal would help to define Cincinnati as a major city through later years, allowing commerce and populace to move easily into and out of the city. This 1900 postcard depicts both the "Myama Canal and Cincinnati Hospital," near Twelfth Street. (Courtesy Earl Clark collection.)

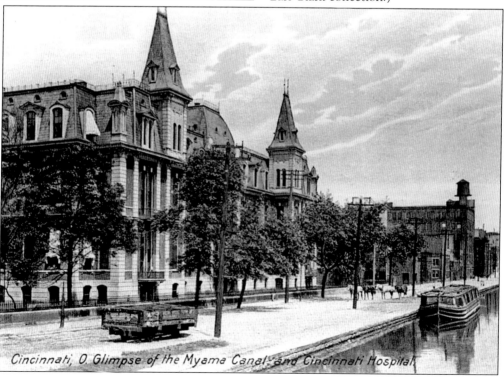

Cincinnati, O. Glimpse of the Myama Canal and Cincinnati Hospital.

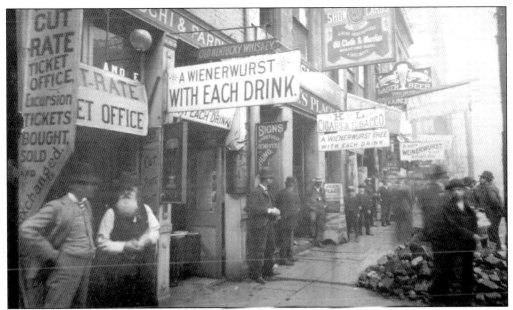

The canal made a direct impact on a large downtown German community in an area contained in a section north and east of the canal. To get there one crossed the Vine Street Bridge over the canal, or the "Rhine," as the local German inhabitants called it after the river in their home country. "Over-the-Rhine" was *the* city hotspot, full of colorful immigrants, Italianate architecture, and restaurants serving rich German cuisine—and many, many taverns and saloons. Patrons could enter nearly every establishment along Vine Street and get a wienerwurst with every drink, in this typical Over-the-Rhine scene, *c.* 1900. But anti-German sentiment caused by World War I delivered a new prejudice against the inhabitants in Over-the-Rhine in the early 1920s, which caused the German citizens to move out. Afterwards, the neighborhoods in Over-the-Rhine deteriorated to the current collection of boarded-up buildings, dirty streets and empty lots. (Courtesy Cincinnati Historical Society Library.)

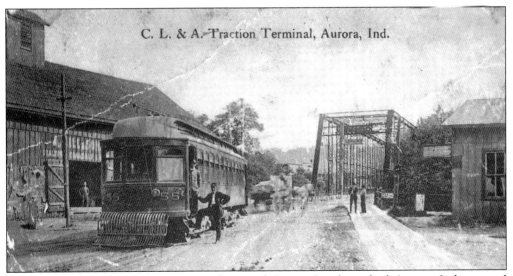

The CL&A (the Cincinnati, Lawrenceburg and Aurora Line) reached Aurora, Indiana, and terminated at the George Street Bridge, *c.* 1904. (Courtesy Earl Clark collection.)

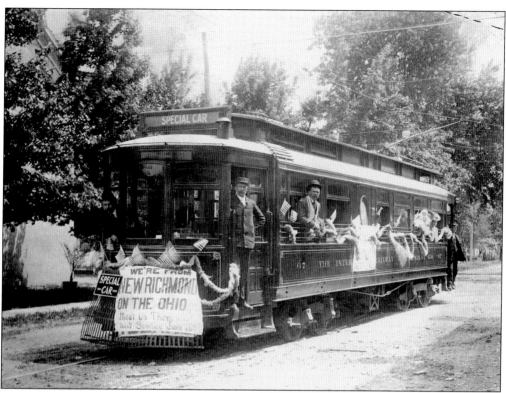

An Interurban Railway and Terminal company car hosted a special event in New Richmond, Ohio, in 1907. (Courtesy Earl Clark collection.)

This Cincinnati, Milford and Loveland car is parked at its depot at Milford Junction on Erie Avenue, near Madisonville, c. 1905. (Courtesy Earl Clark collection.)

It's opening day for the Felicity and Bethel Railroad line in Felicity, c. 1903, and passengers and crew all stop to pose for the photographer. (Courtesy Earl Clark collection.)

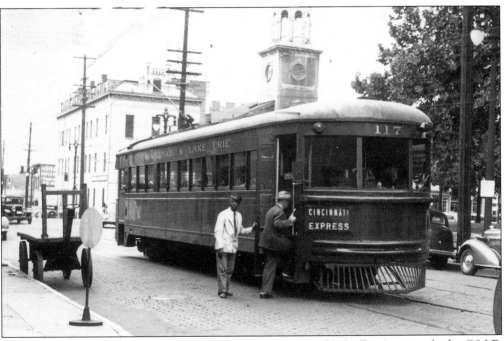

Cincinnati's most popular interurban was the "Cincinnati and Lake Erie," or simply the C&LE. This company offered decades of quality service and had a large and loyal customer base. Its most well known type of car was called the Red Devil, for its high speed and maroon paint job. Some of the Red Devils, called "Parlor Cars," were deluxe passenger cars catered by white-coated porters, allowing the riders to travel in comfort and luxury. In a publicity stunt held on July 7, 1930, to prove that interurbans were faster than airplanes, a Red Devil running on a line south of Dayton raced an airplane flying overhead—and won. Seen here, a white-coated porter assists a passenger into a Red Devil at the Hamilton Station, c. 1935. (Courtesy Earl Clark collection.)

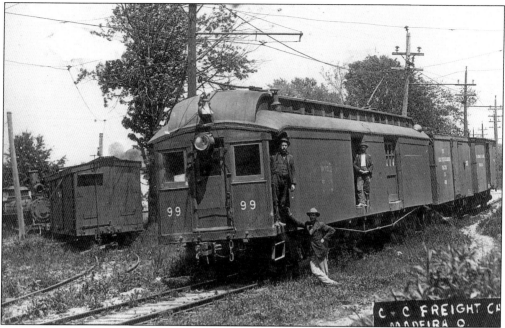

Interurban cars that carried freight only were quite common among all the lines, including this Cincinnati and Columbus engine that is pulling two freight cars in Madeira, Ohio, c. 1908. (Courtesy Earl Clark collection.)

The Cincinnati and Lake Erie line pulled its share of freight, as seen in this photo taken near Beach Park yard, near Cleveland, in 1937. (Courtesy Willis McCaleb collection.)

The canal was used by many Cincinnati children and adults who occasionally would play in the murky waters, using it as a swimming hole in the summer and skating rink in the winter—it is seen frozen here in this turn of the century photograph. The Fairview Incline can be seen in the distance. (Courtesy Phil Lind collection.)

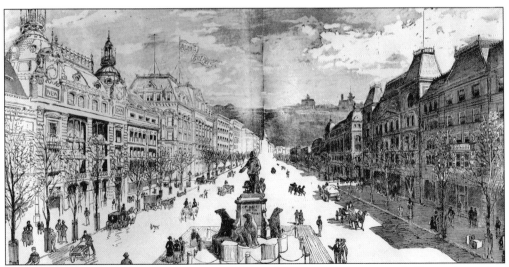

After the *Graphic* ran its drawing in 1884, other newspapers printed illustrations that emphasized either the boulevard or subway motif. Ideas flew around the city concerning the canal bed, the proposed boulevard, and what would go underneath it. In 1884, and again in 1896, City Engineer C.N. Danenhower proposed that the canal be drained and converted into a boulevard. (Courtesy City of Cincinnati.)

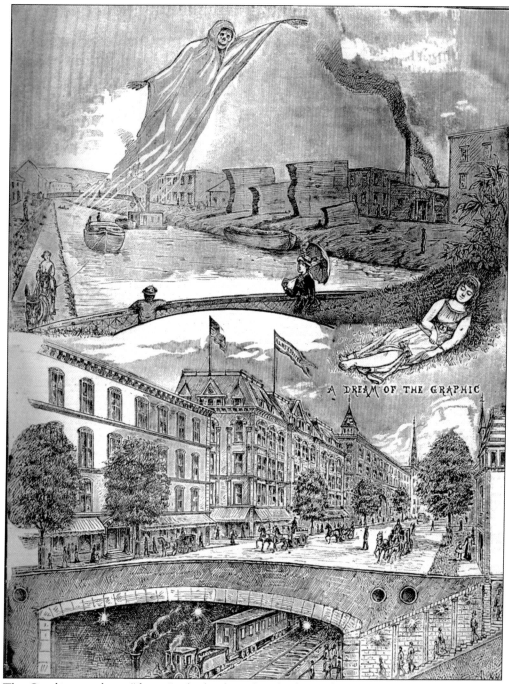

A DREAM OF THE GRAPHIC

The *Graphic* reveals its "dream" of a boulevard and subway. (Courtesy Cincinnati Historical Society Library.)

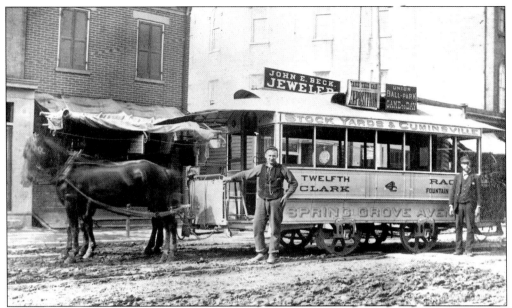

In September 1859 privately owned horse-drawn streetcars began riding new iron rails on Cincinnati streets, and omnibuses slowly started disappearing. Riders called these first horsecar lines "boxes on wheels." The following year, 5 horsecar lines operated in the city limits, and by 1875 14 lines and 45 miles of track criss-crossed the city, employing 550 men and 1,000 horses. The prototypical horsecar seen in this 1885 portrait was painted unique colors (this one might have been yellow) to differentiate between the different lines for the less-literate passengers. This is car No. 4, whose destinations included Race Street, Fountain Square, Clark, Twelfth Street, and Spring Grove Avenue. Its sign on top informs passengers about the Exposition and the game at the ballpark. (Courtesy Earl Clark collection.)

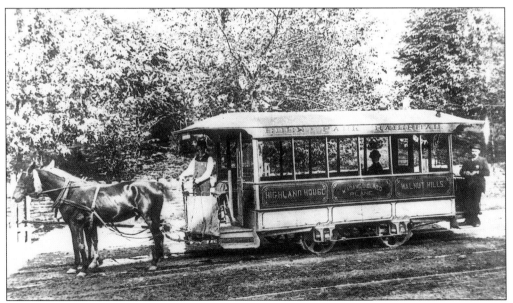

This horsecar was part of the Eden Park Railroad, and also traveled on the Mt. Adams Incline, c. 1888. (Courtesy Earl Clark collection.)

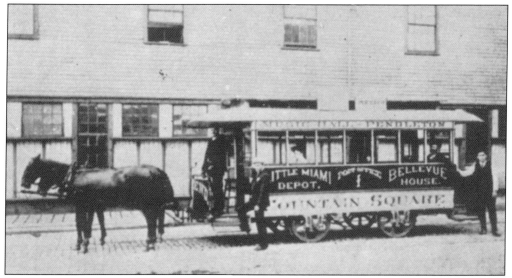

The horsecar in this *c.* 1888 photograph made stops at Fountain Square, Pendleton, and Fifth Street. (Courtesy City of Cincinnati.)

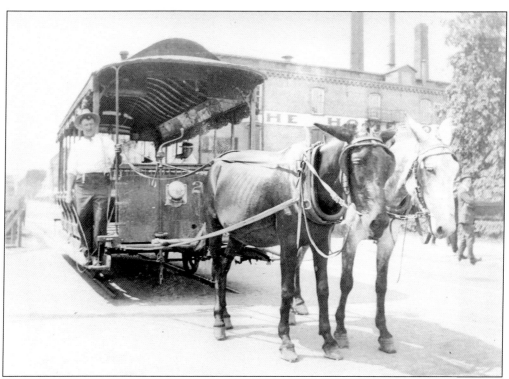

Mules often pulled horsecars, as these did in Middletown, which kept using horsecars until 1918—unlike Cincinnati whose horse pulled its last streetcar in 1904. (Courtesy Earl Clark collection.)

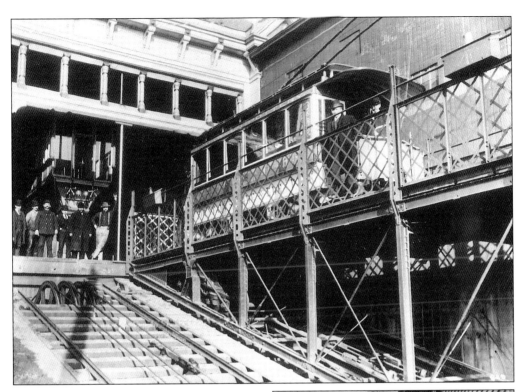

Horsecars couldn't easily and economically climb Cincinnati's steep hills and had to rely on the inclined plane railways for that conveyance. As the nineteenth century neared its close, the city grew upward and outward. The surrounding hills and plateaus developed into new suburbs where wealthier citizens built expensive homes because downtown became too crowded as houses, apartments, tenements, and businesses fought for space. During this expansion, starting in 1872, the inclined plane railways were built to carry the horsecars and their passengers up the hills into the new suburbs. These served as a vital link between the downtown business Basin and the hilltop neighborhoods. In this photo, workers and streetcar pause for a photographer at the top of the Mt. Adams Incline, c. 1905. (Courtesy Earl Clark collection.)

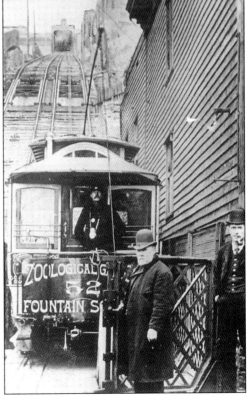

Car No. 52 stops at the bottom of the Mt. Auburn Incline, also known as the Main Street Incline, c. 1889. Note the single trolley pole on the roof of the car. Early streetcars used a single trolley until the CSR forced all streetcars to use the unique, double-trolley system. (Courtesy Earl Clark collection.)

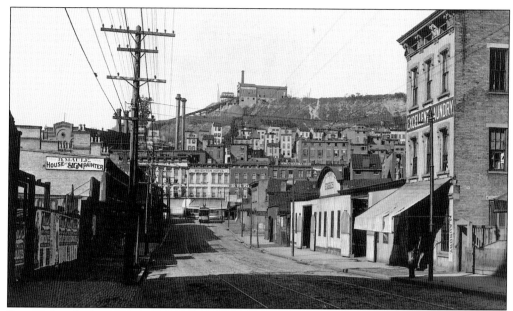

Five inclined planes were built between 1872 and 1894, and were considered cutting-edge technology for their time. These superstructures consisted of one or two sets of long tracks built up the side of a hill. A single platform traveled along each pair of rails pulled by heavy cables: one platform ascended while the other descended, counterbalancing one another, passing at the halfway mark. The platforms could carry a horsecar or wagon, people or freight, or both, for trips that lasted only five minutes. Once on top, the horsecars (later streetcars) reconnected to the street tracks and wires. Here, a streetcar arrives at the top of the Fairview Incline. (Courtesy Phil Lind collection.)

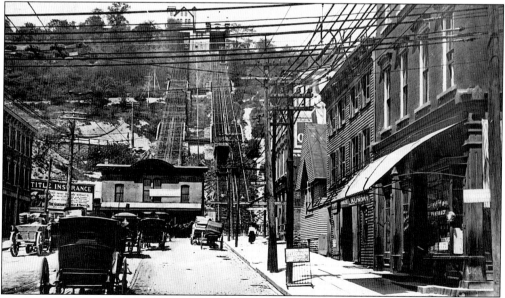

The Price Hill Incline was the only incline that not only used a twin set of tracks, one for passengers and one for freight, but it wasn't built to carry streetcars. Instead, it used "fixed cabs," which carried passengers up the hill, c. early 1900s. (Courtesy Phil Lind collection.)

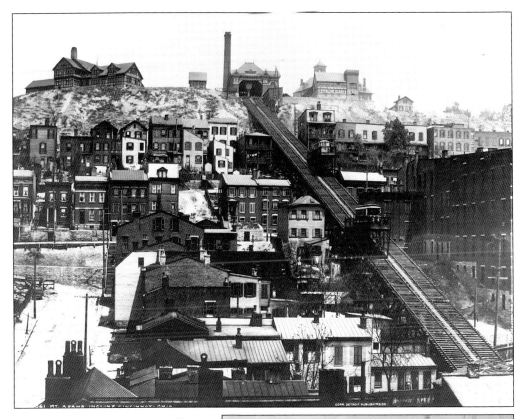

Inclined plane trips were actually quiet affairs. Operators signaled to each other with a series of bells, but once the inclines started moving, the only sound was an occasional hiss of steam from the boilers in the engine rooms that powered the cable system. Passengers often stepped off the car while riding the plane so they could feel themselves soaring silently through the air while ascending the hill. This 1920s photograph shows the nearly full scope of the Mt. Adams Incline. (Courtesy Phil Lind collection.)

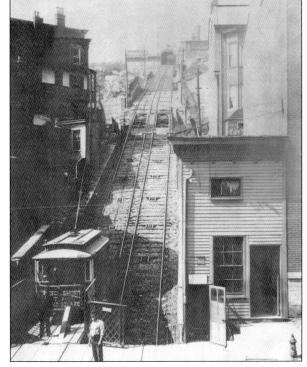

A streetcar arrives at the base of the Mt. Auburn/Main Street Incline. (Courtesy City of Cincinnati.)

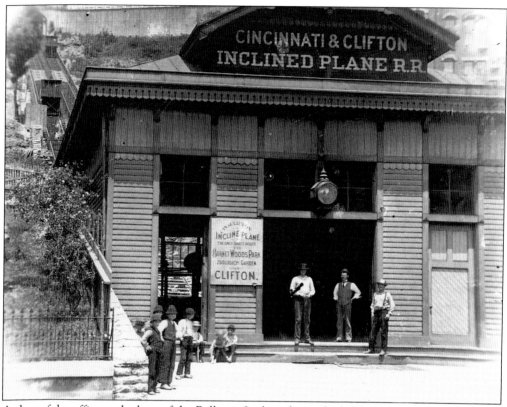

A shot of the office at the base of the Bellevue Incline shows the hill behind it at the turn of the century. The Bellevue Incline only carried small streetcars. (Courtesy Phil Lind collection.)

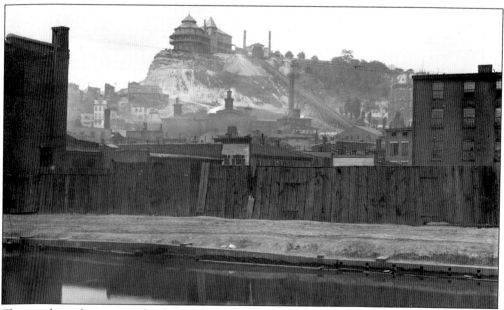

The canal can be seen in the foreground of this shot of the Bellevue Incline. (Courtesy Phil Lind collection.)

Presenting the "Joe Bell" steam dummy, one of the first steam dummies in Cincinnati, built by a local machine shop and named for its creator. This machine pulled "dummy trailers" to and from Sunday picnics at Mt. Lookout Park in the 1870s and 1880s, over tracks with a 3-foot gauge. (Courtesy Earl Clark collection.)

In 1880, eight horsecar lines and two mule lines merged and formed the Cincinnati Street Railway Company, which instituted a system of unified routes and fares. John Kilgour, a company founder, believed that self-propelled cars would have more drive and endurance than horsecars. He had previously tested steam-powered cars on downtown streets in 1860, but the steam boilers' terrific noise terrified nearby horses that were sharing tracks with these loud machines. To fool the horses, car builders disguised the steamcars as *horsecars*, and by 1866 they were known as "steam dummies." Passengers, crew, and a butcher pose at this steam dummy at the corner of Eastern and Tusculum Avenue in 1884. Note the huge boile in the rear of the car. (Courtesy Earl Clark collection.)

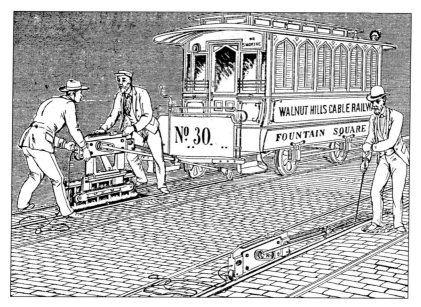

Workers install grips for the cable in this 1886 illustration of a Walnut Hills cable car. (Courtesy Earl Clark collection.)

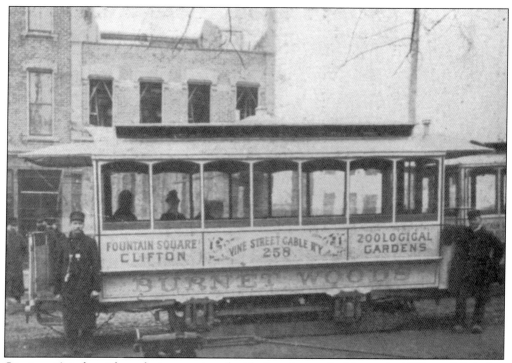

Cincinnati's industrial revolution continued with the advent of cable cars in 1885, modeled after the ones in San Francisco. Cable car lines were built in an effort to pull horsecars up the steep hills, competing with the inclined planes. Moving cables propelled the cable cars, some over 5 miles long, which ran through an underground channel between the tracks. A "grip" on each car clutched the cable and pulled the vehicle along the street. To stop the car, the driver released the grip and applied a hand brake. This Vine Street cable car visited Burnet Woods, Fountain Square, Clifton, and the Zoological Gardens, c. 1890. (Courtesy City of Cincinnati.)

Three

THE SCHEMES

At the turn of the twentieth century, Cincinnati relied primarily on the interurban railroads for transportation and no longer used the canal. But Cincinnati was growing too fast. If the Queen City was going to succeed and keep up with other major cities such as New York and Chicago, then rapid transit needed serious consideration. The *main reason* Cincinnati needed rapid transit was to provide a method of quickly bringing interurban passengers downtown without running on the streetcar lines.

The Cincinnati Traction Company owned and maintained the streetcar lines, and the Cincinnati Street Railway Company leased the lines for their streetcars. The Cincinnati Traction Company owned a monopoly on the lines and stubbornly refused to allow any other company to use them on a permanent basis. Because of their high speed, and because of those with a different rail gauge, not all of the interurbans could use streetcar tracks for conveyance, and needed their own right-of-way into the heart of the city.

The tracks of the city streetcar network all used the "broad gauge" of 5 feet, 2-1/2 inches, and the five interurban lines operating over these tracks used the same gauge. The other four interurban lines used a "standard gauge" of 4 feet, 8-1/2 inches, and were unable to access the streetcar lines at the interurban termini at the city limits. The broad gauge had originally been employed to help the earlier horsecars in an effort to prevent steam railroads from using horsecar tracks for downtown access. The horsecar gauges were set at something other than the standard gauge of 4 feet, 8-1/2 inches—"streetcar broad gauge," six inches wider.

Since four of the interurban lines could not gain entry to the city via the Street Railway Company's lines, and the other five moved slowly into the downtown district, Cincinnati needed a swift way to bring the passengers into the downtown area, and public support was strong. Concerned citizens of the Queen City felt that the city must provide high-speed local passenger transport to connect with the outlying interurban service if the city were to continue to compete with the commercial activity of other large cities. Some city officials felt the same way.

In 1910, Cincinnati's newest mayor, Henry Hunt, observed that what the city needed the most was cheap, rapid, and adequate transportation facilities. He proposed that instead of commuters having to use the slow moving streetcars to travel from downtown to the edge of the city to reach the interurbans, a 15 mile belt-railway could circle the city, which would be partly underground in a subway using the bed of the canal. The Kessler-proposed boulevard, Central Parkway, would be built on top of the subway. Hunt believed rapid transit would be "of greater value to the city than the Cincinnati Southern Railroad and will aid immensely in improving municipal health." He said the creation of the loop meant "the housing problem would solve itself, and the commercial well-being of the city would be stimulated and our economic situation would be benefited."

The City Council passed a resolution in 1911 asking the State to lease certain portions of the canal to the city. In the springtime of that year, the Ohio State Legislature authorized the lease of the canal and said "Permission shall be given to the city of Cincinnati to enter upon, improve and occupy forever, as a public street or boulevard, and for sewerage, conduit and, if desired, for subway purposes, all that part of the Miami-Erie Canal."

Downtown merchants wanted to benefit not only from the predicted increase in business, but they also

hoped the subway would alleviate some of the parking problems caused by workers commuting from the growing suburbs and from across the river in Northern Kentucky. Mayor Hunt took immediate action to quell the problems automobiles were causing to city streets. He persuaded City Council to pass further ordinances to regulate traffic. New laws required traffic to keep to the right in a single file, use horns, gongs or bells for added safety, and vehicles were to use lights at night visible up to 20 feet away.

In March 1912 the machine-controlled City Council authorized Mayor Hunt to appoint a three-man Interurban Rapid Transit Commission to suggest ways of establishing high speed electric railway service. The City Council asked the Commercial Association, the Business Men's Club and the Chamber of Commerce to raise money for a transit investigation. The groups raised $10,320.

The Commission then hired Bion J. Arnold, a Chicago engineer with long experience and proven knowledge of transit matters, to perform the investigation. In October 1912, Arnold presented his "Report on an Interurban Electric Railway Terminal System for the City of Cincinnati" to the Rapid Transit Commission. Arnold thoroughly investigated all aspects of Cincinnati's needs for rapid transit. The report pointed out that because high speed trains were undesirable on city streets, rapid transit would require either elevated structures or a subway through the downtown.

Arnold also recommended utilization of the Miami-Erie Canal as part of the subway. "This plan would save the city the cost of filling the canal and the net cost of the subway could be legitimately reduced by an amount equal to what it would cost to fill the canal so as to make it useful as a boulevard." In late summer of 1912, Ohio Governor Judson Harmon and Mayor Hunt signed a contract that authorized the lease of the canal to the city.

The City Council provided $50,000 for surveys, plans, and estimates, and in June 1913 hired the surveyor Professor George F. Swain of the Boston Rapid Transit Commission. The Commission engaged Boston City Engineer F.B. Edwards to prepare the necessary surveys and preliminary plans. City Engineer Henry M. Waite took charge of the engineering work. A team of engineers was employed and careful surveys were made covering one of the plans suggested by Arnold the previous year. Mayor Hunt's term was up and he was defeated in the 1913 election, but the Republican Party continued the rapid transit program. Two more members were added to the Rapid Transit Commission, and the Commission was empowered by the State to not only issue bonds and plan a beltway, but to build one, too.

Frank Krug replaced Waite as City Engineer in January1914 and took charge of the work as Chief Engineer of the project. In April 1914, the Commission hired the electrician Ward Baldwin to produce estimates for the electrical equipment. Finally, in January 1915, Krug submitted to City Council a report of the work accomplished during the previous two years.

Edwards' and Baldwin's "Report on Plans and an Estimate of the Cost of a Rapid Transit Railway and an Interurban Railway Terminal for the City of Cincinnati, Ohio" proposed four "Schemes," accompanied by thoroughly detailed plans and estimates and proposed routes. The Schemes contained these details:
• Scheme I: Canal-Norwood Belt Line. This line was planned as the entire "loop," to extend from downtown, north up the canal, east through South Winton Place, St. Bernard and Norwood; south through Evanston, then southwest back to downtown. It would cover 15.56 miles with a price tag of over $10.9 million.
• Scheme II: The Downtown Loop Line. Supplementary to Scheme I, would connect Plum, Fifth, and Main Streets to the Belt Line on Canal Street at Plum Street and at Main Street. It would cover another 1.31 miles for additional $1.6 million.
• Scheme III: The Ninth Street Belt Line. Based on Scheme I, this plan omitted that part from Canal and Plum Streets east of the Eden Park Reservoir and added several other streets. It would cover 16.31 miles with a price tag of nearly $12 million.
• Scheme IV: The Pearl Street Belt Line. Also based on Scheme I, it too omitted the part from Canal and Plum Streets east to the Eden Park Reservoir and added several other streets. It would cover 16.46 miles for an estimated $11 million.

Baldwin estimated the cost of rolling stock (the subway cars), power stations, and equipment at $2.16 million, but did not include those costs in his overall estimates. After weighing the pluses and minuses of each scheme, the Commission chose Scheme IV with its price tag of $11 million. The entire length of the line was about sixteen and a half miles lying entirely on private right-of-way with no grade crossings. This Scheme would provide rapid transit in a circular pattern around Cincinnati and its central and eastern suburban areas.

Scheme IV looked like this:

A subway would start at Fourth and Walnut Street, run north on Walnut to the canal, and follow the canal to Ludlow Avenue with two sections in the open.

The line then would follow the canal in the open to St. Bernard, run through the business section of St. Bernard in subway, then extend eastward in open private right-of-way to Montgomery Road in Norwood.

A short piece of subway would run eastward under Harris Avenue to Forest Avenue. The line then would run southeast under the Baltimore and Ohio Railroad to Beech Avenue, and run south in an open subway along the west side of Beech Avenue to Duck Creek Road.

The line then would follow Duck Creek Road and Lake Avenue in the open, to Madison Road, running under Owl's Nest Park and Madison Road in subway; then south in the open along Torrence Road, cutting through the hills in a tunnel to Columbia Avenue.

A road was to be constructed on a concrete elevated structure along Columbia Avenue to Third Street; then along Third, Pearl, and Walnut Streets on a steel elevated structure to Fourth and Walnut Streets.

But having to spend over 13 million dollars, including paying for rolling stock, power stations, and equipment, was not what the Commission had in mind. They ordered the engineers back to work to reduce costs and soon eight modifications emerged. "Modification H" was selected as the most satisfactory one, costing only $6 million. This revised plan provided for a subway to Brighton, and eliminated most of the subway work to Ludlow Avenue by running in the open canal bed, with no grade crossings, to a point opposite Crawford Avenue. Portions opposite Crawford Avenue were eliminated. A surface line was substituted in the canal to St. Bernard, then to Ross Avenue, to Tennessee Avenue, Woodlawn Avenue, Maple Avenue and Smith Road to Duck Creek Road. The remainder of the line was to stay the same as the original Scheme IV.

With the plan fully worked out, the City Council approved the $6 million bond request, and in the spring of 1917, citizens voted to build the rapid transit system. The new ordinance named the Cincinnati Traction Company as the operator of the system to coordinate with the street railway lines. The fare was set at five cents within city limits with universal transfers among all cars of the streetcar/subway system. But later, in March 1918, the ordinance was declared illegal by the Ohio Supreme Court on the grounds that in certain provisions in the ordinance, the city was lending its credit to a private corporation, the Cincinnati Traction Company.

In 1917, though, Cincinnati suddenly faced an unexpected and undesired development: America went to war.

In the 1890s, the Miami-Erie Canal Transportation Company attempted to modernize the canal (and hoped to boost business) by installing an electric rail line on the towpath, to allow for modern electric trains to take the place of mules that ordinarily pulled the boats. This idea didn't pan out because trains had already started to transport goods faster than canal boats. The tracks were all removed by the early 1900s. The tracks can be seen here in this 1901 shot of the Hamilton Station of the canal. (Courtesy Earl Clark collection.)

Interurbans ran all over the Midwest, connecting large cities to small towns, and Ohio had more miles of interurban track than any other state in the nation. Nine major rail lines converged on Cincinnati. The cars of five of the lines accessed the center of the city over the local streetcar tracks at an average speed of about six mph to the downtown terminal. In addition to receiving and distributing their regular interurban passengers within city limits, these cars also operated as city streetcars. The cars of the other four lines stopped at or near the city limits; and in order to complete their trip, the passengers transferred to city streetcars. This shared arrangement did not make an ideal "fast" transit system. In this photo, a large crowd of well-dressed ladies, and a few gentlemen, pose in front of this Cincinnati and Columbus interurban car in Hillsboro, c. 1908. The C&C wouldn't last much longer as a train, and would soon be replaced by buses. (Courtesy Earl Clark collection.)

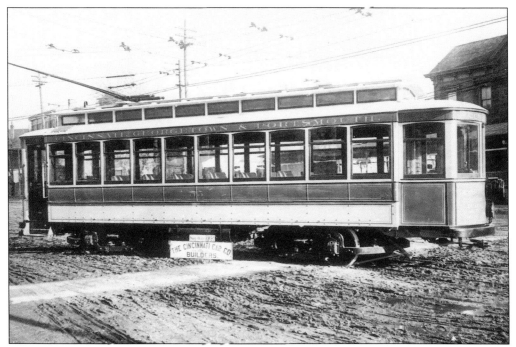

The Cincinnati, Georgetown and Portsmouth line was one of the few interurbans that used the wide rail gauge, and could therefore enter downtown Cincinnati, c. 1905. (Courtesy Earl Clark collection.)

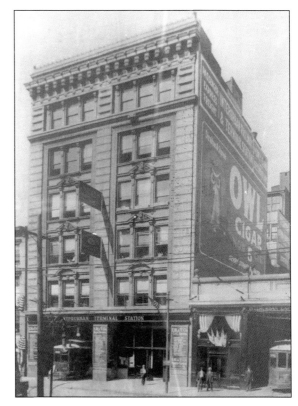

The Interurban Railway and Terminal company, located downtown on Sycamore between Fourth and Fifth Streets, ran lines to Lebanon, New Richmond and Bethel. Circa 1905. (Courtesy Earl Clark collection.)

After his election in 1910, Mayor Henry Hunt wanted to improve the quality of life in Cincinnati. He determined that his main challenge was relocating the working-class and poor out of the tenement houses of the Basin and into the newer and more sanitary suburbs "to secure a real home for every man, woman and child in Cincinnati." (Courtesy Cincinnati Historical Society Library.)

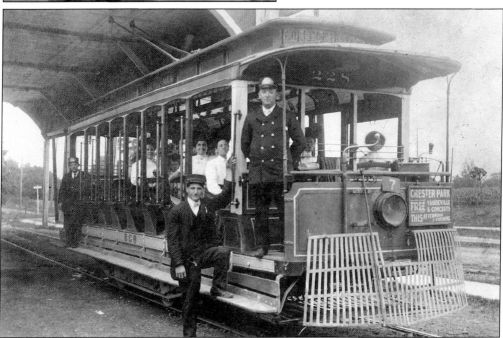

Not all streetcars were enclosed. This "open summer car" at Hamilton Avenue and North Bend Road, c. 1905, advertised "free vaudeville and concerts at Chester Park." (Courtesy Earl Clark collection.)

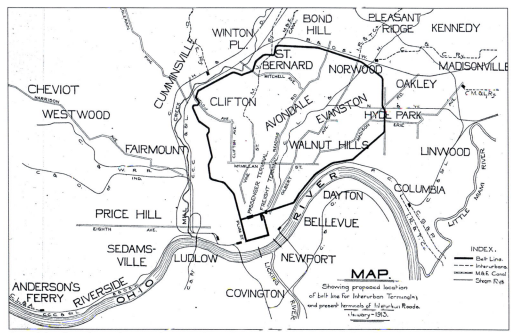

Arnold's plan showed a rapid transit line that would use the canal right of way and encircle the city in a belt loop. (Courtesy City of Cincinnati.)

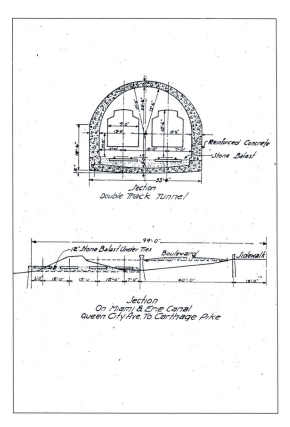

The Arnold Report suggested six workable subway plans for the city. In the most favorable report, Arnold said, "Rapid transit is one of Cincinnati's greatest needs. . . . Usually Cincinnati would be too small to justify the large expense for an elevated road or subway, but on account of the unusual topography and restricted downtown, [it] might be an exception." He advised the building of an interurban terminal located in the heart of the city at Fountain Square and suggested rapid transit lines from this terminal to or near the city limits to form a comprehensive terminal system. Furthermore, a high speed limited "express service" with a uniform gauge to all suburbs was needed, at least during the morning and evening rush hours. (Courtesy City of Cincinnati.)

Edwards and Baldwins' 1914 map detailed the entire area affected by the four schemes, as well

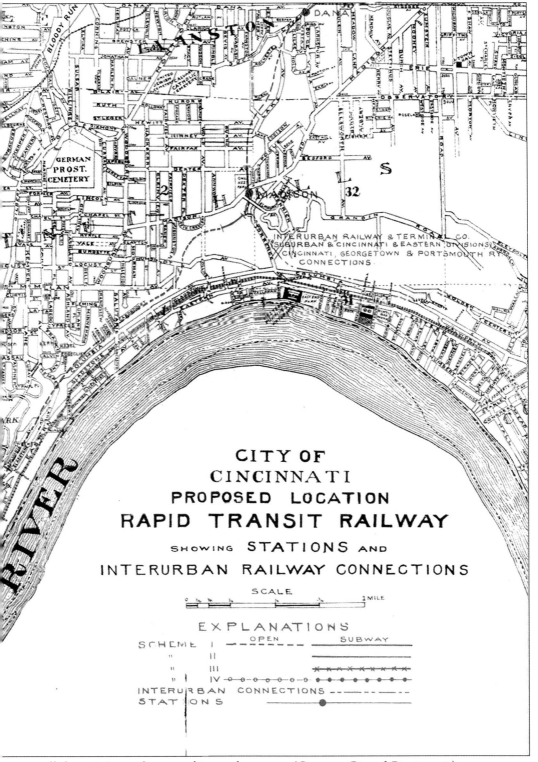

CITY OF
CINCINNATI
PROPOSED LOCATION
RAPID TRANSIT RAILWAY

SHOWING STATIONS AND

INTERURBAN RAILWAY CONNECTIONS

SCALE

1 MILE

EXPLANATIONS

	OPEN	SUBWAY
SCHEME I		
" II		
" III		
" IV		
INTERURBAN CONNECTIONS		
STATIONS		

as all the existing and proposed interurban stops. (Courtesy City of Cincinnati.)

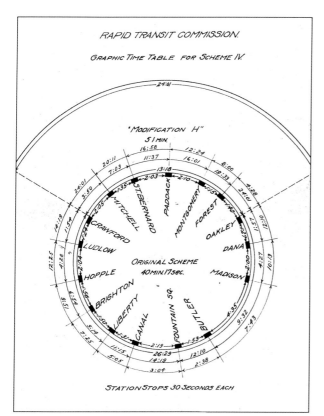

"Modification H" cut a lot out of Scheme IV. This graphic timetable estimates the travel time for the subway train in 1916. (Courtesy City of Cincinnati.)

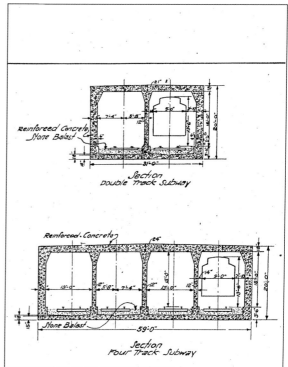

Arnold included diagrams of the cross-sections of the tunnel and subway. (Courtesy City of Cincinnati.)

Four

SUBWAY
CONSTRUCTION

General Pershing led American troops into Europe in June 1917, and thousands of soldiers from Cincinnati were shipped overseas. And like other industrial cities, Cincinnati's factories started producing war materials. Machine-tool shops, valve factories, and electrical works furthered the war effort by manufacturing rifle bores, lathes for shell-casings, parts for ships, and motors of all kinds.

Since no capital issues of bonds were permitted during the war, and the Supreme Court had invalidated the ordinance of April 17, subway construction could not proceed. On May 18, 1918, the City Council decided to issue $80,000 of the $6 million bond to proceed with contract drawings. However, on July 18, 1918, engineering work was stopped for the remainder of the year when the funds completely ran out.

The war ended on November 11, 1918, meaning the soldiers from Cincinnati could start returning home. The Queen City celebrated the armistice by making as much noise as possible: factory steam whistles blew, church bells rang, and everyone banged on drums, pans, garbage cans, and anything else that would make noise. Parades and victory celebrations continued into the night under a sky made bright with rockets and torches. The war was over and Cincinnati could get back to work as it looked to the promising new decade.

The Commission now discovered that the subway loop could not be built in its entirety for the $6 million previously voted for in 1916 because construction costs had doubled during the war. Funds had been appropriated for the project though, so work would continue. Besides, at least the subway portion had to be done in order to build Central Parkway on top.

In the spring of 1919, the City commissioned Moses Blau, Chief of the State Bureau of Inspection and Supervision of Public Offices in Columbus, to study the rapid transit project and its financial impact on the city. He computed the costs of the improvements to the loop at about $13 million even with the details outlined in "Modification H." Some examples are given of several of the leading items entered into the work estimated at $6 million, and what actually was paid under the contracts awarded—the excavation of the subway, which in 1915 was estimated at 80 cents per cubic yard, was contracted at $1.25 per cubic yard in 1919; reinforced concrete had doubled from the 1915 estimate of $8 to $16 per cubic yard; and the price of reinforced steel, estimated at $55 per ton, actually cost $105 per ton in 1919.

Therefore, the Commission decided to build only the western part of the system and not attempt construction of the eastern portion or lay the rails. So for $6 million, the line built would start at the canal at Walnut Street, go westward along the canal and north through St. Bernard, then eastward to Norwood and south to Oakley.

Work on the drawings started again in early 1919 when the funds became available. In the summer the contract for Section 1 was awarded to D.P. Foley General Contractors. This section would include subway construction from Walnut Street to Charles Street, including building the Race Street station. At last, it looked as though construction would soon begin.

As the date of groundbreaking loomed closer, the public started realizing the importance of how the new subway system would affect the city. In the January 21, 1920 edition of *The Cincinnati Enquirer*, the president of the University of Cincinnati, Doctor Charles W. Dabney, said:

The subways will mean a bigger and better city in which to live. The proposed subway would bring people to Cincinnati who at present do feel like living in the downtown section of the city and cannot afford to live in the more expensive suburbs. After a day's hard work one does not feel like riding forty-five minutes or an hour on a streetcar, when most of the time is lost because of slow movement of traffic in downtown streets. The subway would mean that new subdivisions for the working man and the man of moderate means would be opened in all outlying districts of the city.

Construction began in January 1920 with D.P. Foley General Contractors lifting the ground out of the canal. The contract for Section 2, subway construction extending from Charles Street to Oliver Street, was awarded to Hickey Brothers at the same time the Union Gas and Electric Company was using the water in the canal. Work commenced after the canal was drained, and Hickey Brothers finished Section 2 in November 1921.

Hickey Brothers won the next contract—for Section 3— for subway work from Oliver Street to 350 feet north of Mohawk. Work commenced in September 1920 and was finished in February 1923.

The Fred R. Jones Company won the contract for Section 4 in 1921, extending from 350 feet north of Mohawk to Brighton. The Brighton Station also would be built within Section 4. Construction began on June 2 and was halfway finished near the end of the year. This section would end the subway work in the canal, except for the isolated subways in Norwood. Jones Company finished the work in January of 1923.

In December of 1921 Hickey Brothers won the contract for Section 5, which extended above ground in a tunnel for one and-a-half miles from Brighton to Hopple Street. Much of this construction required blasting the hillside with dynamite, and Hickey finished construction in February 1924.

Section 6 was a three and-a-half mile open stretch from Hopple Street to Mitchell Avenue. Once again, Hickey Brothers won the contract in the spring of 1922, and started working on the section in June of the same year. They finished in October 1924, which completed about six miles, excluding the laying of rails and furnishing of stations.

Hickey Brothers won the next contract for sections 7, 8, and 9 and began construction in July 1924. These aboveground sections, and some subway sections in Norwood, extended from Mitchell Avenue to Oakley, a distance of five and-a-half miles. Hickey planned to finish in early 1925, but by the end of 1924, only about 28% was complete.

Unexpected expenses and other delays began to cause financial worry. As a result, the Commission started cutting some sections out of the scheme: an area near Duck Creek Road to Madison Road in Oakley, and a gap in St. Bernard from Ross Avenue to and including the subway at Carthage Pike.

In the summer of 1927, Mayor Seasongood ordered the Commission to conduct another study of the city's current rapid transit needs. Together City Council and the Cincinnati Street Railway Company (the CSR, having replaced the Cincinnati Traction Company a year before) engaged the New York engineering consultant firm, the Beeler Organization. This firm would survey the entire traffic situation in the city and outlying territory and make new recommendations for operation of the rapid transit system.

The Beeler Report was submitted to City Council in the fall of 1927. Beeler found that even though Cincinnati was relatively small, "the rugged topography and the wide spread of the industrial sections emphasize the necessity for [rapid transit] here." Beeler recommended that the downtown station be situated directly under Fountain Square with the platform under the center of the Square between Vine and Walnut Streets with a track on either side. One track would be used for rapid transit service, the other for interurban. The report suggested building more stations: Brighton, Ludlow, St. Bernard, Paddock, Montgomery, Forest (in Norwood), and Oakley.

Beeler also pointed out problems in the existing construction:

Wooden stringers on which to place the running rail are in place in the subway sections, but nothing has been done in the way of track construction. The existing stations are completed only in the rough. The walls will have to be finished and the necessary equipment installed, such as shelters, booths, turnstiles, toilets, etc. Nothing has been done in the way of providing rolling-stock, distribution system, a signal system, or shop and storage facilities. Other minor items, such as lighting, ventilating, fire protection, and fencing the right-of-way will have to be taken care of before the line can be operated.

The report also questioned whether the city would be willing to spend an additional $10.6 million to complete the system.

Soon after the Beeler Organization submitted its report to the Commission, the Cincinnati Street Railway Company engaged Beeler for a supplemental survey of costs and returns that would result from proposed further construction of the loop.

Beeler submitted its new report in the summer of 1929. It urged that the subway line be extended to Winton

Place in order to be able to reach the car shops that would build and maintain the trains. This extension also would allow easy access for the C&LE and the CH&D from their present terminal at Spring Grove and Crawford. The report also recommended truncated service using conventional 1920s rapid transit cars.

Even though Beeler reported that the Street Railway Company's total revenues would increase by $391,326 the first year in operation, any money concerns were moot at this point. Cincinnati had no more money to spend chasing the subway, didn't want to raise the money, and just wanted to forget that the whole thing ever happened. The terms of the members of the Rapid Transit Commission were going to expire on January 1, 1929, and then the Board of Rapid Transit Commissioners would cease to exist. Mayor Seasongood, successful in reforming the City Council, now wanted the Commission (which was appointed during the Boss era) out of office. In December 1927, he sought to delay further activity with rapid transit work. "I believe a better study of this entire matter may be made," he said, "when that bunch is out."

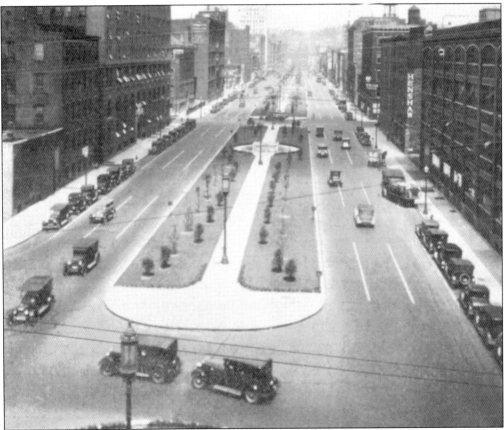

Central Parkway opened for traffic on Monday, October 1, 1928, amid parades and speeches on top of the hidden tunnels. The Parkway Celebration started at noon when Mayor Seasongood closed City Hall, proclaiming Monday to be a half-holiday. Court was adjourned and mail deliveries were cancelled for the afternoon, and parades and celebrations lasted all week long. The subway project has been on hold ever since. (Courtesy City of Cincinnati.)

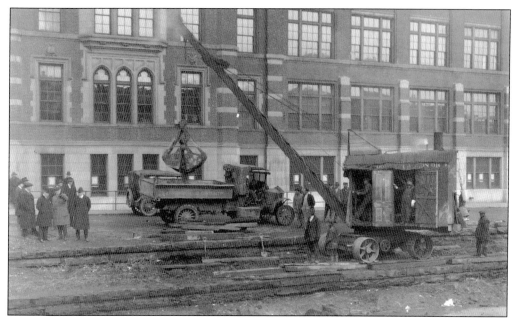

Almost two weeks after national Prohibition went into effect and closed all of Cincinnati's saloons and breweries, the first steam-shovel load of earth was lifted from the canal at Walnut Street. It was on Wednesday, January 28, 1920. Mayor John Galvin himself gave the signal to the steam-shovel operator who dug out that historic first hole in the canal. In *The Cincinnati Post* that day readers saw the picture of the breaking of ground with the headline, "Look at this twice, for it shows start of loop." D.P. Foley finished Section 1 in December, 1921. (Courtesy City of Cincinnati.)

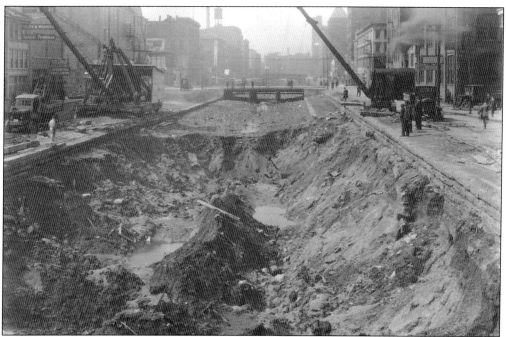

Construction work in Section 1 continues in the canal, seen here west from the Sycamore Street Bridge, March 15, 1920. (Courtesy City of Cincinnati.)

Prohibition loomed right around the corner, spelling bad news for thirsty Cincinnatians. (Courtesy *The Cincinnati Post*, used with permission.)

The construction crew uses an outhouse in April 1920, just like the modern-day construction site. (Courtesy City of Cincinnati.)

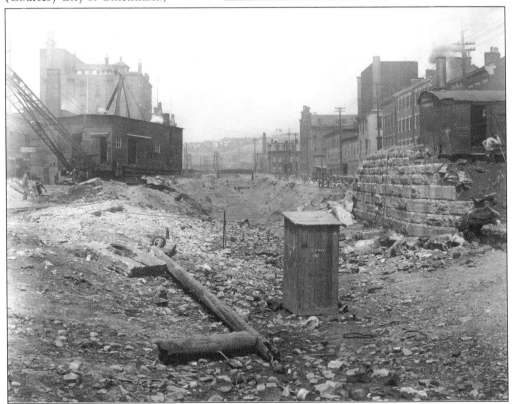

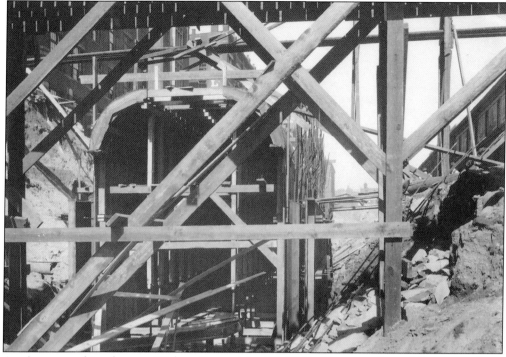

A tube starts taking form on Walnut Street, May 26, 1920. (Courtesy City of Cincinnati.)

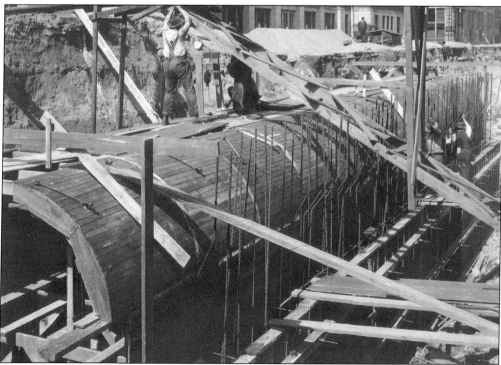

Another subway tube on Walnut shows more progress, May 26, 1920. (Courtesy City of Cincinnati.)

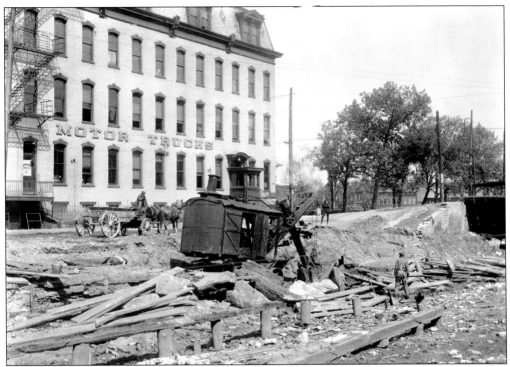

D.P. Foley begins construction just south of the Twelfth Street Bridge, May 26, 1920. (Courtesy City of Cincinnati.)

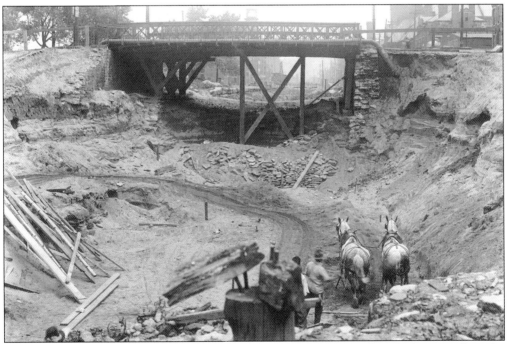

Heavy construction equipment in 1920 included using horses, seen here looking north at the Twelfth Street Bridge, June 19, 1920. (Courtesy City of Cincinnati.)

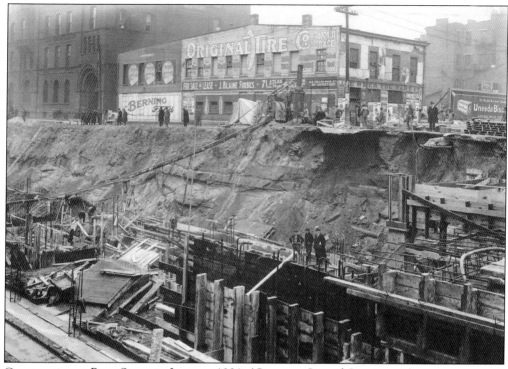

Construction at Race Street in January, 1921. (Courtesy City of Cincinnati.)

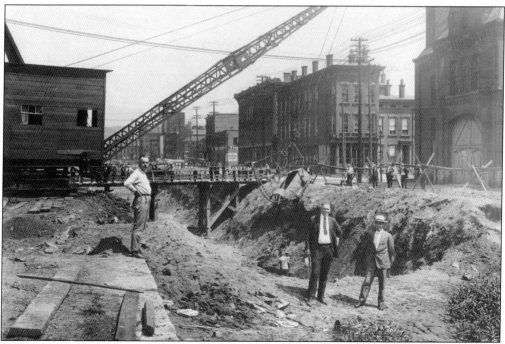

The canal has been drained and is now being shoveled out in Section 2, south of Fourteenth Street. Pictured are "Mc and Elmer" according to the back of the photo, July 8, 1920. (Courtesy City of Cincinnati.)

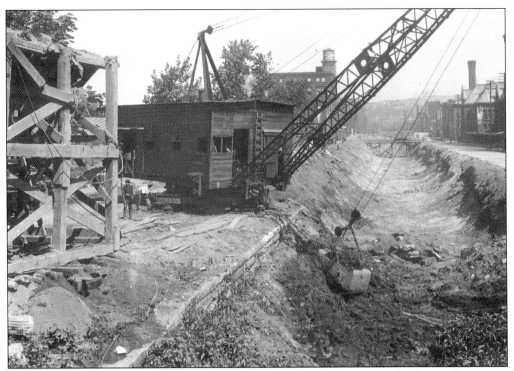

More of the canal is removed, north of Fifteenth Street, and a temporary bridge can be seen in the background, July 29, 1920. (Courtesy City of Cincinnati.)

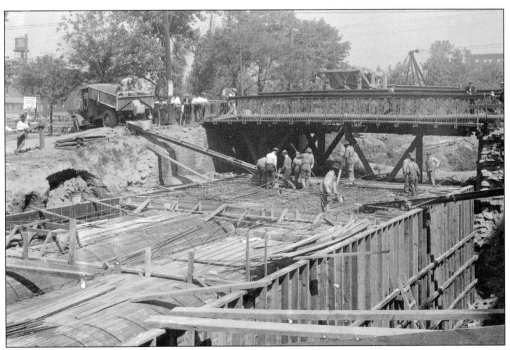

The subway takes form as concrete is poured into the section south of Twelfth Street, July 29, 1920. (Courtesy City of Cincinnati.)

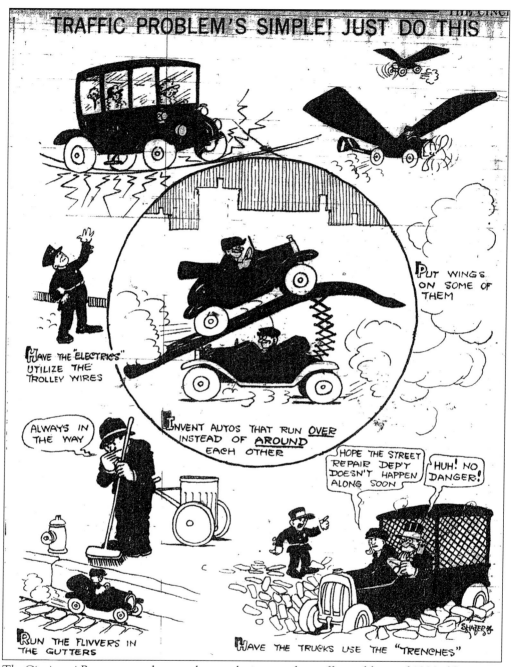

The Cincinnati Post presented some clever solutions to the traffic problems of 1920. (Courtesy The Cincinnati Post, used with permission.)

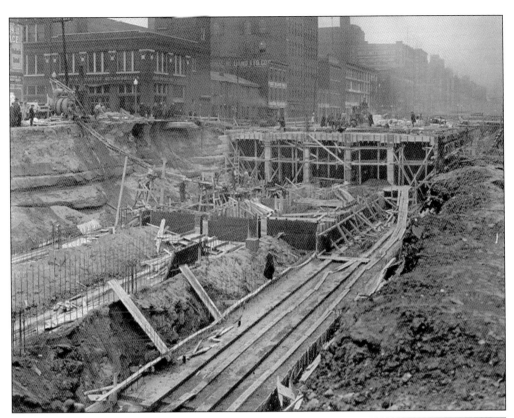

More concrete gets poured over a more elaborate section of subway, east from a point opposite "Advertisers' Block," January 28, 1901. (Courtesy City of Cincinnati.)

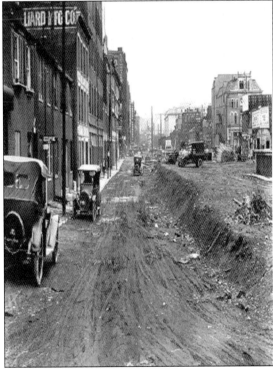

Canal Street is open for business, and is already being used, east from Race Street, after D.P. Foley finished their work, August 21, 1921. (Courtesy City of Cincinnati.)

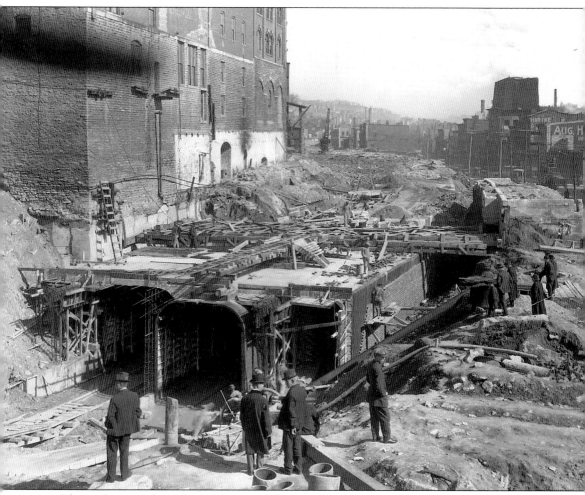

The underground Brighton Station in Section 4 is under construction on March 15, 1922. The large building on the left, in those days a brewery, still stands today. (Courtesy Phil Lind collection.)

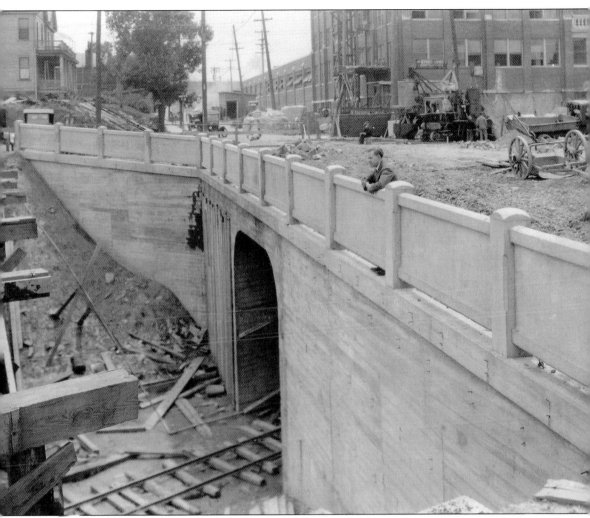

During Hickey's construction process in 1924, Cincinnati had to cut a special deal with the City of Norwood to allow the subway to pass through that city. (Since Norwood is a city within the confines of Cincinnati, Cincinnati had to negotiate with Norwood in order to access the streets for rapid transit. The same situation existed in St. Bernard.) Also, a sewer had to be built in St. Bernard to take care of storm water that drained into the canal. Then another delay ensued during subway construction in Norwood. The Cincinnati Traction Company insisted on temporarily installing tracks in place of the ones removed from Harris Avenue, which later was found to be impractical and a complete waste of time. These delays stalled construction of sections 7, 8, and 9 for several months and pushed some of the work into the winter months, when due to the unsuitable weather, construction was slow. The final sections were finished in February 1927, two years behind schedule. In this scene, a man overlooks the subway construction on Section Avenue in Norwood, June 3, 1926. (courtesy City of Cincinnati)

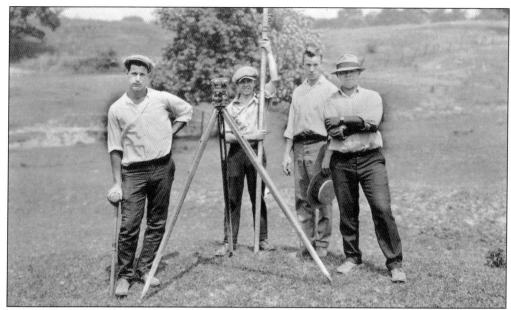

Members of Lee Parker's survey crew, from left to right, Harold, Babbs, Lee, and Phil pose on Druhe Property between Paddock and Reading Road, July 7, 1924. (Courtesy City of Cincinnati.)

The Clifton Avenue Station is finished, just waiting on completion of the rest of the subway system. That hat and case presumably belong to the photographer, August 28, 1924. (Courtesy City of Cincinnati.)

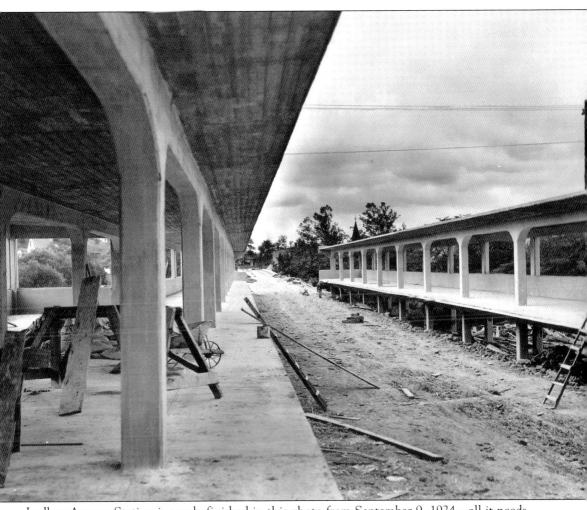

Ludlow Avenue Station is nearly finished in this photo from September 9, 1924—all it needs is a subway. (Courtesy City of Cincinnati.)

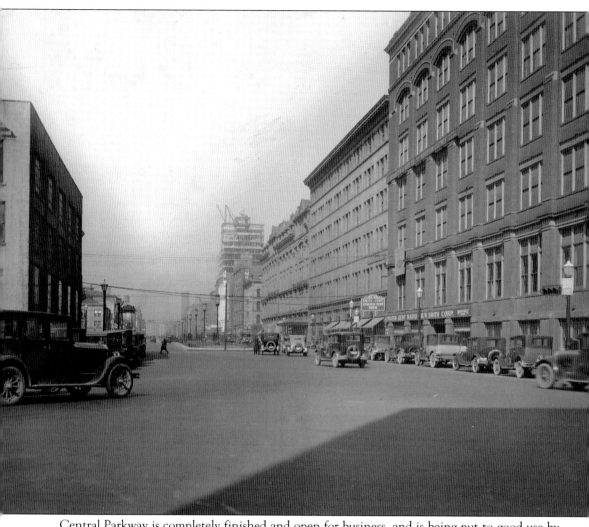

Central Parkway is completely finished and open for business, and is being put to good use by automobiles in this photograph from 1928. (Courtesy City of Cincinnati.)

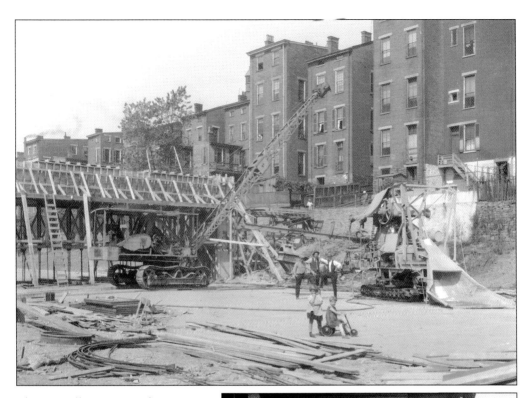

The Baymiller Street Pedestrian Bridge, built as a footbridge over Central Parkway, is under construction, September 24, 1927. (Courtesy City of Cincinnati.)

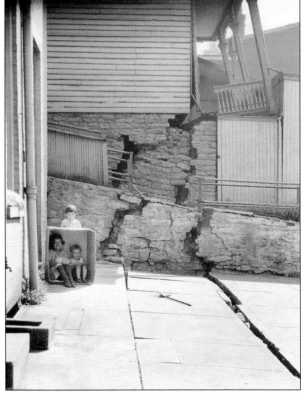

Problems cropped up that slowed progress and sometimes made the subway idea seem unwise. Because of the topography of the canal and composition of the earth, erosion in the hills caused by rains created unforeseen problems—hills began to fall away and houses cracked open like eggs, like Rosenberger's house on McMicken, September 7, 1922. (Courtesy City of Cincinnati.)

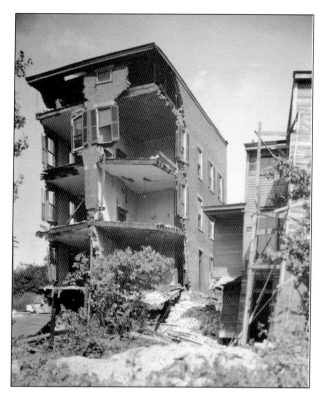

Early in 1922, Brighton residents living on the hill complained that blasting for the subway was damaging some of the neighborhood's homes. Dealing with this issue delayed construction for over two months and resulted in payment of nearly a quarter-million dollars for damages. More unpredictably, sometimes as soon as a portion of the canal was emptied and cleared out, a hard rain would fall and the walls of the canal would collapse into the bed. Houses on McMicken literally started falling down after rain showers. This photograph was taken September 18, 1927. (courtesy City of Cincinnati.)

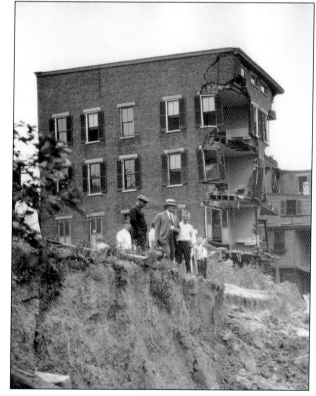

Here again we see evidence of the great destruction that resulted directly and indirectly from the blasting. The ground has literally slipped away, and the house is obviously falling apart. This photo was taken September 25, 1927. (Courtesy City of Cincinnati.)

More damage is seen here; notice the huge crack in the foundation form of this house on McMicken, September 25 1927. (Courtesy City of Cincinnati.)

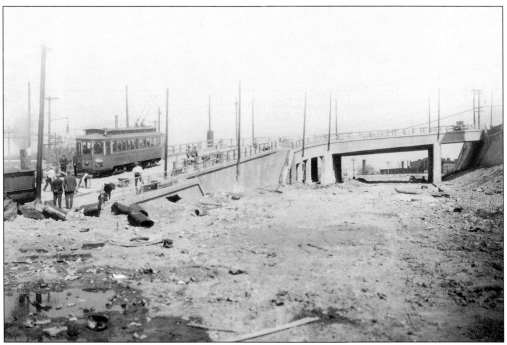

A streetcar rides down the somewhat-completed Brighton Bridge on May 7, 1928. (Courtesy City of Cincinnati.)

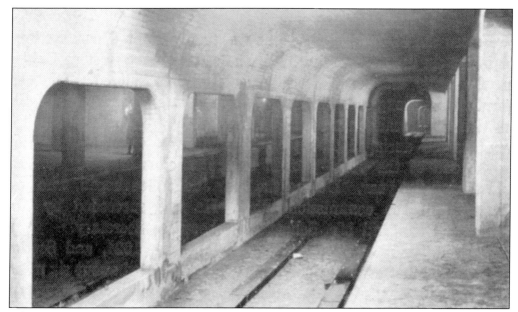

When construction was complete, the rapid transit line consisted of a downtown subway, graded open-cut right-of-way with bridges north of the subway, and six stations—three in the subway, at Race, Liberty, and Brighton; and three in the open-cut section, at Marshall, Ludlow, and Clifton Avenues. The resulting structures were concrete two-level subway stations. The stations were not furnished with *anything*; they were built as bare-bones concrete construction,. Liberty Station is seen here in 1928. (Courtesy City of Cincinnati.)

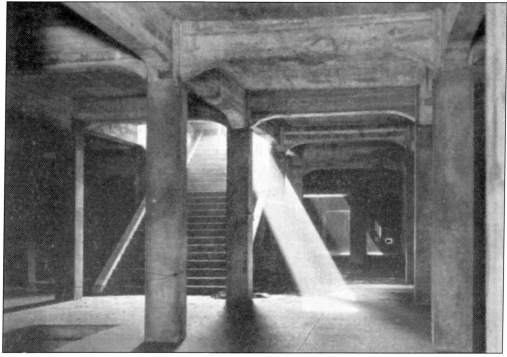

The sun shines in on the finished Race Street Station, 1928. (Courtesy City of Cincinnati.)

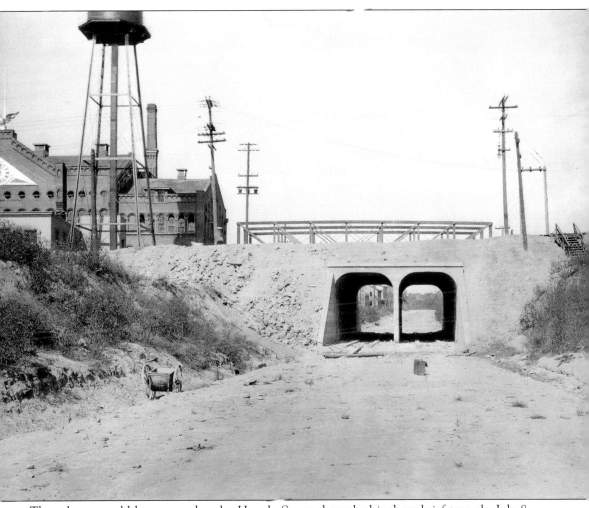

The subway would have passed under Hopple Street through this these brief tunnels, July 8, 1924. (Courtesy City of Cincinnati.)

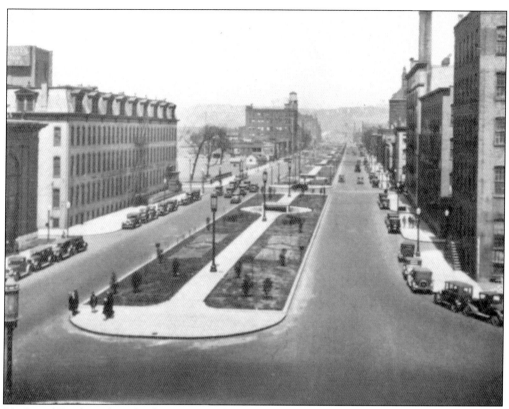

"A Grand Boulevard" indeed, was Central Parkway in 1928. (Courtesy City of Cincinnati.)

Central Parkway at Brighton, north of Baymiller, looks to be a peaceful road in this photograph, taken July 11, 1928. (Courtesy City of Cincinnati.)

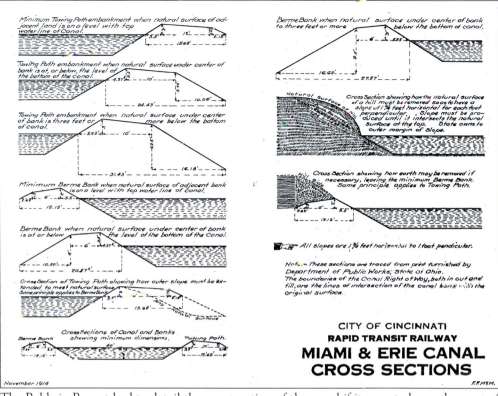

The Baldwin Report had to detail the construction of the canal if it were to be used as part of the rapid transit system. (Courtesy City of Cincinnati.)

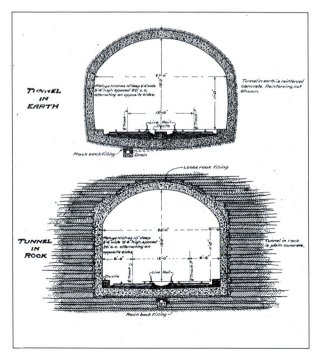

Baldwin detailed the construction of the basic subway section. (Courtesy City of Cincinnati.)

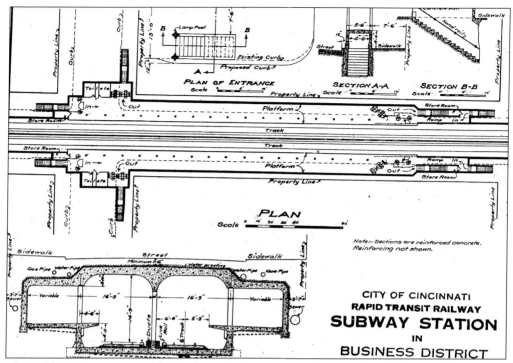

The Baldwin Report created basic plans of a downtown subway station. (Courtesy City of Cincinnati.)

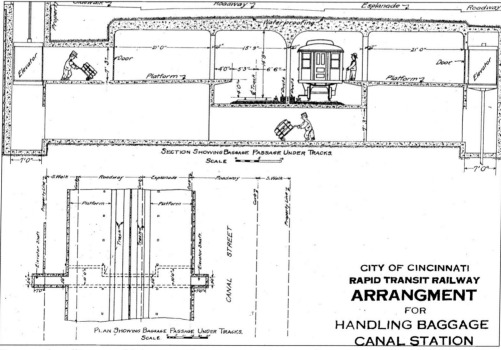

Baggage handling would have to be an integral part of a subway plan. (Courtesy City of Cincinnati.)

Details as simple as fencing for stations could not be overlooked in a plan. (Courtesy City of Cincinnati)

A subway car 70 feet long by 10 feet wide, similar to those in use by Boston and New York (in 1914), was seen as adequate for Cincinnati. This car could carry 200 passengers and could attain a speed of 45 mph on a 2% upgrade. Three wide doors operated by compressed air were provided on each side of the car, and the average station stop would be 15 or 20 seconds. The cars would be made of steel and very little wood, to keep fire damage to a minimum. (Courtesy City of Cincinnati.)

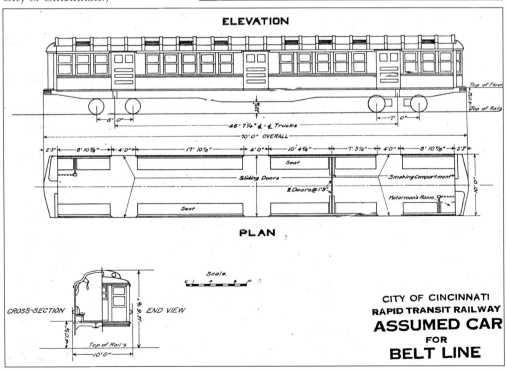

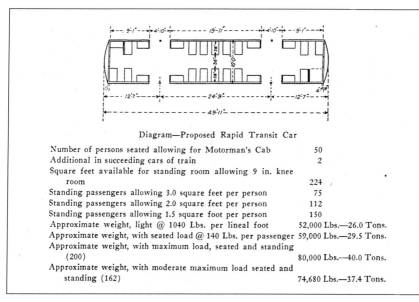

Diagram—Proposed Rapid Transit Car

Number of persons seated allowing for Motorman's Cab	50
Additional in succeeding cars of train	2
Square feet available for standing room allowing 9 in. knee room	224
Standing passengers allowing 3.0 square feet per person	75
Standing passengers allowing 2.0 square feet per person	112
Standing passengers allowing 1.5 square foot per person	150
Approximate weight, light @ 1040 Lbs. per lineal foot	52,000 Lbs.—26.0 Tons.
Approximate weight, with seated load @ 140 Lbs. per passenger	59,000 Lbs.—29.5 Tons.
Approximate weight, with maximum load, seated and standing (200)	80,000 Lbs.—40.0 Tons.
Approximate weight, with moderate maximum load seated and standing (162)	74,680 Lbs.—37.4 Tons.

Beeler's suggestions in 1927 were similar. An all-steel car, 49 feet, 11 inches long, and 10 feet wide was the car Beeler thought to be ideally suited for the subway. The car would weigh about 26 tons and offer a seating capacity of 50 passengers, a comfortable capacity of 162 passengers, and a maximum loading capacity of 200. The choice lay between individual cars with automatic couplers, which was a common type consisting of a car body mounted on two trucks, and the two-car articulated unit. The latter type was composed of two car bodies mounted on a truck at each end of the unit and an additional truck supporting the junction of the two bodies. The chief advantage of the articulated unit was that a given carrying capacity could be secured at a lower first cost, and the cost of operation was about nine percent less than that of equal capacity provided by single units. Beeler determined that the single car unit would prove at least as economical as the articulated unit. (Courtesy City of Cincinnati.)

Beeler computed and graphed the hourly load demands in his rapid transit schemes. (Courtesy City of Cincinnati.)

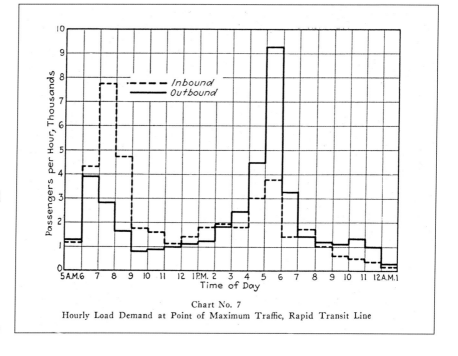

Chart No. 7
Hourly Load Demand at Point of Maximum Traffic, Rapid Transit Line

Five

FAILURE

In its entirety, the subway plan had sounded so promising. Cincinnati's traffic problems would be solved, access to surrounding suburbs would be fast and easy, and travelers from all of the interurbans could be carried quickly into the downtown business section. But along with the political corruption, numerous unexpected developments plagued the rapid transit construction process.

Inflation caused by the Great War nearly doubled the costs of construction. Consequently, the city could not build the entire rapid transit loop as estimated before the war. The city built only what it could for the $6 million that it had, resulting in a couple miles of subway tunnels and some aboveground construction.

The automobile also was gradually eliminating the need for rapid transit. In 1910 Mayor Hunt had no idea that eventually nearly every family in the Queen City would own a car. In the 1920s, the automobile made it possible for more and more citizens to move away from the older and somewhat rundown sections of the city to the cleaner, quieter neighborhoods on the hills. New highways and viaducts were built to connect the city to the suburbs, which eliminated a key need for rapid transit routes.

The automobile also killed the interurban railroad service. People no longer needed to take traction lines to other cities; they now drove themselves in affordable Model Ts. Because the traction lines began to go out of existence, a subway would not be needed inasmuch as the interurbans were one of the main reasons the city needed the subway in the first place.

Meanwhile, City Planning in Cincinnati was in full swing. The United City Planning Committee (UCPC), created in 1915, argued that proper city planning could cure many of the city's physical problems, including transit issues. Adopted in 1925, the Master Plan of the UCPC suggested that downtown congestion could be relieved through new traffic regulations including the rerouting of streetcars, the widening of some streets, new one-way streets, and parking, trucking and delivery restrictions. Rapid transit was seen as "financially undesirable," and the money "that would have to be spent in completing the loop could be far more profitably spent in developing main radial thoroughfare. . . ." City planning, then, helped eliminate the need for rapid transit.

By 1925, the Charterite Party had taken over City Hall with Mayor Seasongood at the helm. In the spring of 1926, the mayor asked City Council what would happen if changes were made in the Rapid Transit Commission following an inquiry from a member of the Committee on Law about the Commission. The mayor had already researched the Commission and the subway construction and found many interesting facts and little-known details. From this information, he created a report that he released to City Council later that spring.

He found that in 1916 the Commission had promised not to spend any of the $6 million bond until a plan of operation was created, and until they found some organization to own and operate the line. The mayor pointed out that the pledge had been totally ignored by the Commission and that all of the money had been spent.

He found that the Commission continually ignored the advice of experts concerning whether or not the city really needed rapid transit. A number of reports, published from 1917 through 1923 by various committees, pointed out that the proposed route would be unprofitable and that the people were not being

told the whole truth about loop costs; that the money already spent on the subway, $3 million by 1921, was wasted and the project should be abandoned; that the construction and operation of the loop would "remain a financially prohibitive undertaking within the life of the present generation"; that the conditions under which the rapid transit system would operate were completely different since 1914—by 1924 only five of the original eight interurban lines, the principal source of income for rapid transit, were operating; and that the subway line would run through a less-populated district, and thus might not produce ridership sufficient to break even. The Rapid Transit Commission filed such reports without discussion.

The Commission, Seasongood found, had even refused to consider a previous mayor's statements. Mayor Galvin, in a letter of April 4, 1919, pointed out that ". . . we should consider the future needs of our city and provide facilities that will be of advantage, and that we should likewise know how this loop is to be operated if it is to be built." Automobiles had become serious competition to the interurbans, which, Mayor Galvin said, "appears to remove the principal incentive for building the loop." These comments made by the mayor fell on deaf ears at the Commission.

Mayor Seasongood also held that the Commission had stalled building the subway and Central Parkway. The Parkway bonds were voted on in 1924, and by 1926 no construction work had begun. He also asked why Cincinnati should spend its money for the benefit of Norwood and St. Bernard, which weren't technically part of the city.

As to the Parkway project delay, the mayor learned that the Commission was continuing to employ an unsuitable Chief Engineer. The Upson Report observed that the Chief Engineer of the rapid transit project also was the Chief Engineer of the City. Since he ran both departments, he received an extra $4000 a year. The Report questioned the business ethics associated with paying two salaries to the same individual for filling two positions: "Either the general supervision of the rapid transit design and construction should be a part of the general duties of the City Engineer's office . . . or a special engineer should be employed for the Rapid Transit Commission, leaving the City Engineer free to devote his whole time to important civic duties."

In the late fall of 1924 the Central Parkway Association asked the Commission to appoint an engineer solely for the rapid transit project. The Commission responded by deciding that the Parkway Project would be handled exactly the same as the construction of the rapid transit system handled by Frank Krug as Chief Engineer. Mayor Seasongood noted that the estimates of Krug had misled the citizens by underestimating the amount of the $6 million bond. Even before the war, he felt the amount estimated was not enough to complete the loop.

Mayor Seasongood concluded his report by stating that a new Rapid Transit Board should be appointed. The new Board would offer an unbiased opinion as to what would be the best solution for the problems created by the Commission.

The next year the Beeler Organization was employed again to study Cincinnati's current transportation needs, and released their report in the fall of 1927. After studying the report, Mayor Seasongood stated publicly on December 22 that he wanted to delay further rapid transit work until "that bunch is out," the bunch being the Rapid Transit Commission, which would cease to exist January 1, 1929. Seasongood wanted to wait until they were out of office before starting lease negotiations with the Street Railway Company. "I am not in favor of permitting that bunch to have a hand in these negotiations," he said. "It will merely give them the color of doing something when, in fact, they have nothing to do at all."

The Mayor also thought that the 1927 Beeler Report was "Hamlet, without the ham," and needed to be studied more closely by the City Manager. He said that Beeler privately had admitted to him that a rapid transit system would not be successful in any city which did not have a population of at least one million.

He criticized the fact that that the Commission had raised the salary of their legal counsel, Ed Schorr, by $2000. He said that Schorr refused to pay a traffic violation fee of two dollars and intended to file an appeal. "If his time is taken up in these matters," he said, "certainly there is very little left to devote to the Commission's business that would justify the salary given him." He insisted that the whole policy of the Commission had been one of opposition to the city, fuming, "That is the bunch you are supposed to deal with."

Understandably, the Rapid Transit Commission was not happy with Seasongood's criticisms. Commission Vice President Philip Geier stated that the citizens of Cincinnati were well aware of the work performed by the Commission. He pointed out that many of the delays came from the Supreme Court's determination of the unconstitutionality of the contract with the Cincinnati Traction Company, and that the city could not start subway construction during the war.

Geier noted that the Beeler Report had been secured through the cooperation of the Rapid Transit Commission, City Council, and the Street Railway Company. He questioned why the report had to be

checked by the City Manager. "The report has been accepted and approved by everyone having to do with it. It has received commendation from the press and everyone who has examined it. Why not go forward now with the negotiation of the contract and the putting to use of this greatly needed artery of traffic?"

Geier recalled an earlier time in Seasongood's administration when the mayor suggested that the members of the Commission should serve without pay. Geier told Seasongood that if the mayor would serve without pay, then Geier would serve without pay. And in 1927, Geier renewed his proposition and said that if the mayor would return the salary paid him in 1927, and serve during 1928 without pay then Geier would "cheerfully forgo my salary for the same years."

Geier responded to Seasongood's criticisms of the salary increase of Ed Schorr by stating the work done by Schorr had been detailed, time consuming, and had been "splendidly performed." Geier pointed out that Schorr had been complimented on the "thoroughness of the great task of the preparation of the Central Parkway assessments."

Finally, Geier said, "If the mayor has now found sufficient vent for his venom, I suggest that he, with other members of Council and the Commission, proceed with the city's business."

Seasongood then asked that if Schorr did all the work that Geier said he did, then "what did the Rapid Transit Commissioners do? And what is there left for them to do now and what is there for Schorr to do? If they had worked as much as they talked, the rapid transit system would have been built by this time." Seasongood added that Geier had fictionalized the conversation about serving their respective times without pay.

Seasongood concluded his remarks by sarcastically wishing the Rapid Transit Commission the compliments of the season "and hope they will make a New Year's resolution to resign."

These political ping pong games failed to accomplish anything for the rapid transit plan at large and only served to stall the work further. Seasongood stood by his decision to hold off proceedings until after the Rapid Transit Commission was gone after New Years 1929. After the stock market crash later that year, the Depression would kill the project altogether.

Or would it? Seasongood wanted the project stopped, so it stopped. But he was out of office in 1930, and no one could predict what Cincinnati might need in the future.

The subway dream was not dead yet.

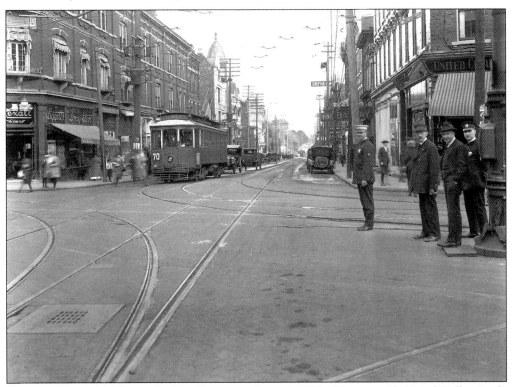

A view of East McMillan at Peebles Corner in the mid-1920s. (Courtesy Phil Lind Collection.)

Marshall Avenue station is completed—all it needs is a subway. (Courtesy Cliff Scholes collection.)

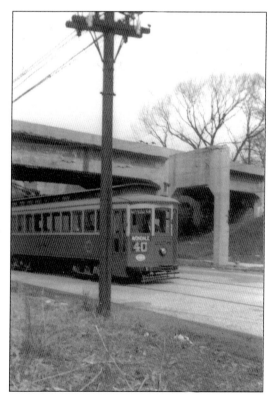

An Avondale car cruises along Mitchell Avenue underneath a completed rapid transit underpass in the early 1930s. (Courtesy Phil Lind collection.)

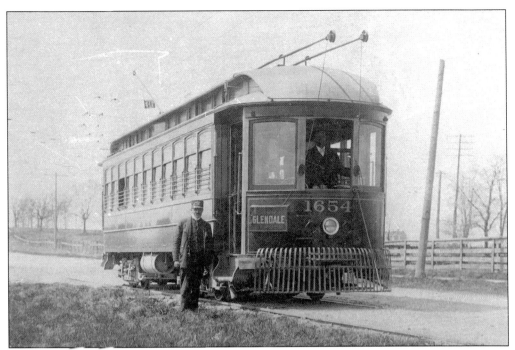

A conductor poses next to a Glendale Line Interurban car, c. 1925. (Courtesy Earl Clark collection.)

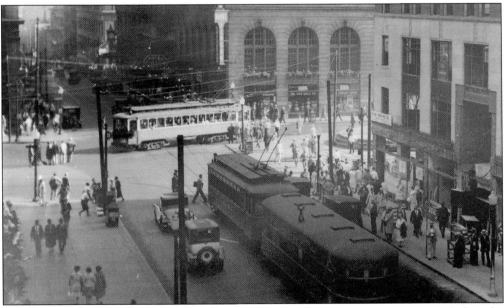

Two taxicabs drive beside a streetcar pulling a trailer car (to increase passenger capacity) at the corner of Fifth and Walnut, c. 1929. Between 1922 and 1927, the number of automobiles in Hamilton County increased by 126 percent. By 1927, there were 88,000 automobiles in Hamilton County, each car carrying an average of 1.8 passengers. The automobiles in Hamilton County carried some 16 million riders in and out of the downtown district annually. These figures showed that people simply preferred their cars to public transportation. (Courtesy Earl Clark collection.)

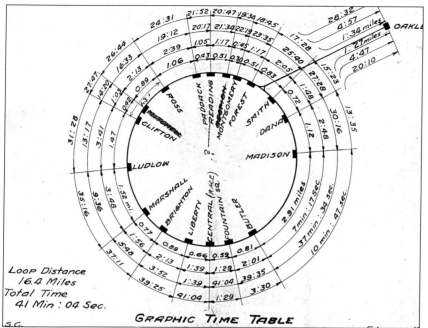

The Rapid Transit Commission released this modified Graphical Time Table in 1921. (Courtesy City of Cincinnati.)

GRAPHIC TIME TABLE

Loop Distance 16.4 Miles
Total Time 41 Min : 04 Sec.

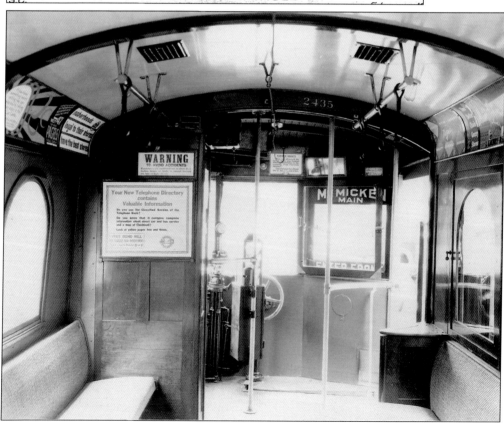

Cincinnatians became very familiar with this look—a typical 1920s streetcar interior. (Courtesy Earl Clark collection.)

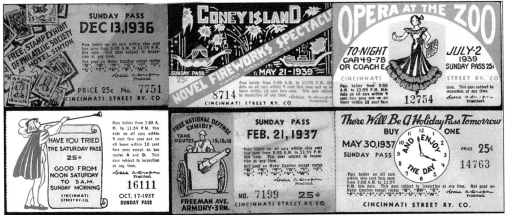

Since autos were taking over public transit, streetcar patronage was dwindling fast. Buses with rubber tires had already started appearing around the city, offering newer public transportation. To combat this competition, the Cincinnati Street Railway Company started selling Sunday passes in 1926 in an attempt to induce more people to use streetcars on weekends. It proved to be enormously popular to everyone, even the new automobile owners. For only 25 cents, the Sunday pass enabled a passenger to travel anywhere in the city by streetcar, all day long. A family could go to the zoo, Coney Island, and a host of other attractions all for the cost of a single pass. Teenagers would spend all day Sunday "riding the rails" with their friends and end the day by giving the pass to someone else to use until the streetcars stopped running that night. (Courtesy Phil Lind collection.)

In 1925, at least 19 different unregulated bus lines were operating in heavy traffic districts around the city. Although the novelty appealed to streetcar riders, the buses' disadvantages were that they didn't offer transfers, nor did they run enough buses to accommodate rush hour crowds. The city was forced to issue ordinances and policies to regulate those and any future bus lines. This very early motor bus in the early 1920s was put into service because it replaced the Cincinnati and Columbus Interurban, which went out of business partially due to the fact that it was to utilize the rapid transit system. (Courtesy Earl Clark collection.)

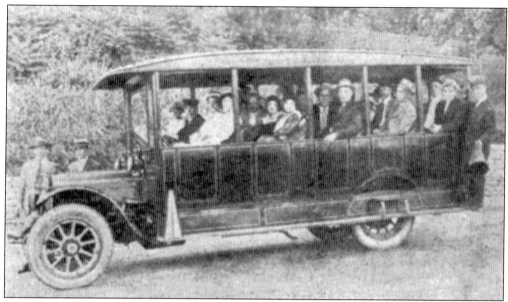

Although the many different bus lines competed fiercely against each other and electric streetcars in 1925, it was actually in 1913 that unregulated bus service started appearing in the city. These early motorbuses were merely trucks rigged with temporary seats giving passengers a bouncy, noisy and uncomfortable ride, such as this "Auto Sight Seeing Car" that operated in 1917. Hard rubber tires and bench-like seats supplied "comfort and convenience" for the riders not using a streetcar. (Courtesy City of Cincinnati.)

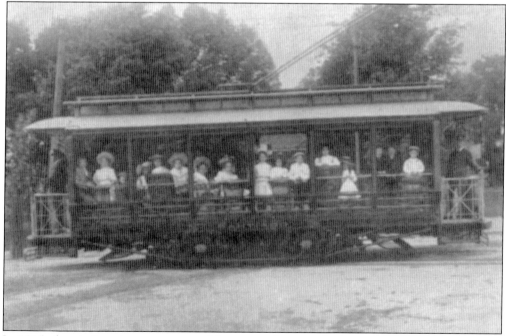

In 1915, the city's society matrons could engage a luxuriously decorated Parlor Car, a "parlor on wheels" for entertaining or for showing the city to out-of-town visitors. But after November 1915, the parlor cars were ordered out of service. (Courtesy City of Cincinnati.)

By the end of 1926, the Cincinnati Street Railway Company operated 62 motor coaches like this one parked in front of UC, including some double-deckers, and had bus routes running all over the city. Eventually, a series of mergers would bring the bus system under the control of the Cincinnati Transit Company. (Courtesy Phil Lind Collection.)

By 1926, Cincinnati had built many new roads, and transportation choices inlcuded automobiles, streetcars, buses, and a dying interurban system. Now it looked as though the city definitely did *not* have a need for rapid transit. But construction on the project would continue until the money completely ran out. That would take only one more year. Here, automobiles, streetcars, and pedestrians jam the streets at Fifth and Walnut Streets in 1928. (Courtesy City of Cincinnati.)

Six

THE 1930S

THE SUBWAY WILL LIVE ON

After the Stock Market Crash of 1929, the United States experienced its first—and worst—economic depression that would take years to run its course. By 1931, over eight million people in the country were unemployed. President Hoover proposed an emergency Reconstruction Finance Corporation and a Public Works administration to Congress to try to help the country cope with this national crisis. The New Deal programs of President Roosevelt were still a couple of years away.

The Queen City was coping with the Depression in the same ways every other city was. People from all different backgrounds stood in the same bread lines, and held bowls for the free soup from the soup kitchens. Family members dressed in tattered and patched clothing stood next to former businessmen still dressed in their suits while college graduates walked the streets begging for jobs. Movie theaters became refuges for those wanting to escape their current plights. Theaters started showing double-features in an effort to boost admissions; many unemployed executives whiled away their afternoons laughing at Charlie Chaplin in *City Lights* and the Marx Brothers in *Monkey Business*. Prohibition still held the country in its grip, but over three thousand speakeasies housed in basements, river houseboats, and hidden summer cottages kept Cincinnatians drinking happily, but illegally. One report mentioned that liquor distillers even set up shop in the subway tunnels to keep the booze flowing.

Economic depression or not, in 1931 Cincinnati remembered the dream of the *Graphic*, although quite a few people called the wasted subway "Cincinnati's white elephant" and remained skeptical about a continued pursuit of this dream. However, these were the 1930s, and the former stick-in-the-mud city officials were now out of City Hall. This meant no more Seasongood, no more Rapid Transit Commission, and no more inter-office bickering.

Officials who still supported the idea were wary of putting an appeal for funds before taxpayers to complete the project and put it into operation. The supporters recognized the inherent problems and asked many questions: What are the possibilities of the immediate issuing of a bond to complete the project so the subway could be used? How much money would be needed? How would the present transportation system be affected? Is this a good time to force the rapid transit issue or would it be better to wait until the Depression ended when the city and country were back on their financial feet?

Many people were afraid that further delay would kill it altogether and wanted to revive the issue all over again. Walter A. Draper, president of the Cincinnati Street Railway Company, said that for $5 million the rapid transit line could be integrated into a system that utilized all forms of public transportation.

Draper suggested a rapid transit line could run from Central Parkway and Walnut Street to a point near Spring Grove Cemetery, charge a fare of ten cents, and break even. The city could then extend and enlarge the system as needed to expand to outlying sections of the city. This idea would follow the same rapid transit plan used in New York, Philadelphia, Boston, and Chicago.

On February 21, *The Cincinnati Post* stated: "It is an inevitability that Cincinnati in the near or far future will be asked to vote a bond issue to complete its rapid transit. Will it be willing to pour more money into the project? In the meantime a concrete and steel embryo lies dormant. And the day is coming when the rumble of speeding cars will be felt where once a sluggish green canal lazed through the heart of the city, cutting its business sector and its picturesque Over-the-Rhine district."

And that was 1931. The Queen City would spend the next few years dragging itself through the Depression and getting back on its feet. It wasn't until 1936 that the city decided to once again explore rapid transit. This time, the Engineers' Club of Cincinnati was commissioned "to study and report on the rapid transit situation in the city and on the possibilities for making use of the present rapid transit property."

Among its findings, the Engineers reported that there would be no practical value in using the subway tubes as parking garages, freight lines, merchandise storage, or the running of automobiles through the tubes, and needed to improve and make better use of what it already had. The whole rapid transit plan had been created to address the needs during the 1910s. Twenty years later, the needs had changed. If it could not be converted to modern needs economically, "it should be forgotten—as part of the toll of progress."

Later that June, the city's Metropolitan Transportation and Subway Committee was commissioned to create a new Traffic Survey Report. Committee Director Laurent Lowenberg and Chief Engineer Bruce Maxon released a the survey to City Manager C.A. Dykstra. Lowenberg's report, like the earlier Engineers' Club Report, pointed out that a city the size of Cincinnati could not afford to build and maintain a rapid transit system like that of New York.

"Cincinnati's transportation problem is rather one of moving great masses of people over comparatively short distances at reasonable speeds," he said. "The origin and destination counts made by the survey clearly shows 45 percent of all our traffic has its destination in the central business section of the city, a mere fraction of the total area." The report recommended a subway loop for downtown and the completion of the existing subway as part of a new citywide rapid transit system.

Measurements of the existing subway tubes showed that they were big enough to accommodate the present streetcars run by the Street Railway Company. The cars would enter the system at Western Hills Viaduct, Central Parkway and Vine, Eighth and John, Reading Road and Broadway, and at Gilbert Avenue and East Court Street. Of the 3,166 streetcars that traveled daily in the congested areas of downtown, 2,530 would be taken off of the streets, resulting in a considerable reduction of pedestrian and vehicular accidents.

The best part was that the plan would utilize all of the present rapid transit construction. But slightly over two miles of new subway construction would be required. Along with this, new and existing subway tunnels needed to have their stations finished, and would have to be equipped with track, lighting equipment, signal system, electrical distribution system, and fire protection. Construction was estimated to take only 18 months.

The City Council discussed whether or not to pursue the Engineers' Club's Plan. These discussions lasted through the next three years, and nothing concrete ever resulted.

In February 1939, City Manager Clarence Sherrill suggested that City Council adopt a "detailed engineering study" to adapt the subway underneath Central Parkway for automobile use. This plan called for the extension of the tunnel under Walnut to a point below Third Street where it would open into an enormous outdoor riverfront parking lot with a capacity of 15,000 cars. Sherrill said that by running autos through the tunnels, a much greater volume of traffic could be moved than if the streetcars were placed underground.

The Metropolitan Transportation and Subway Committee discussed the impracticality of Sherrill's plan and reinforced what they already knew: the tubes were not suitable for automobile traffic. Reasons for this included the ventilation of exhaust fumes, motorists' psychological reactions to driving through the restrictive tunnels, and the fact that the tubes simply could not handle a sufficient volume of traffic to be worth the cost; not to mention the fact that a parking lot built to handle 10,000 cars would require the acquisition of about ten city blocks.

Sherrill's idea fell by the wayside because construction costs for such a parking lot were too prohibitive. But the city eventually did decide to proceed a little further with Lowenberg's plan of extending the subway tubes and running the streetcars underground. The city spent $10,000 for a team of three specialists "to settle once and for all" what to do with the unused subway. On May 7, 1940, Henry M. Brinckerhoff and Ernest P. Goodrich, engineers from New York, and Professor John S. Worley of the University of Michigan released their Traffic Survey Report.

While the engineers and City Council thought that the report offered many excellent suggestions, Cincinnati's citizens were divided. As a matter of fact, since the subway tunnels had sat unfinished and unused for so long, it was suspected that the older generation had almost forgotten about the tunnels, and that the younger Cincinnatians hardly knew of its existence. To get an idea of what the present generation thought of the new plan, *The Cincinnati Post* surveyed its readers in 1940 and found out that many more people on average wanted the city to use the subway as part of a mass transit system than to simply discard it. A subway still was intriguing, even after all those years, and represented an expensive investment that

could still be utilized with a modern rapid transit system.

This project represented a major undertaking for the Queen City and would revolutionize the downtown traffic pattern. It would place public transportation underground in a subway loop, and widen the boundary streets of the central traffic district to make possible the counter-clockwise distribution of surface traffic. As a corollary, Cincinnati had more motor vehicles than the city of Boston and twice as many cars per person, and yet Boston had put its streetcars underground many years before.

The method of financing the project was of utmost importance, especially from the standpoint of property owners. Could the community reasonably sustain the resulting financial burden? Other expensive projects already were underway. The Millcreek Valley needed flood control and the proposed barrier dam at the mouth of the Millcreek could cost between $5 million and $20 million. A gigantic program of sewage disposal and river purification was underway which ultimately would reach a cost of approximately $20 million. And Cincinnati school buildings required replacement at the rate of about one per year. In addition, a public library was sorely needed in the near future.

When everything was considered together, the resulting total reached a startling figure and justified the hesitation before more civic improvements were considered. Furthermore, interest charges associated with bond issues added greatly to the initial cost of the long-term improvements, not to mention the $1,000 a day subway interest the city was still paying.

So, would the Queen City actually be able to undertake a project of this magnitude? The plan went to City Hall, where it would languish while the political gears slowly turned. At the same time political gears were turning in other parts of the world, only on a much larger scale. The subway project again would have to be put on hold because on December 7, 1941, Japanese air squadrons flew to Hawaii and attacked Pearl Harbor.

As it did over two decades earlier, America went to war again.

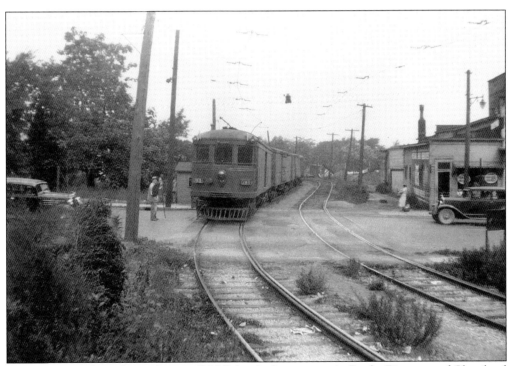

A crossing guard stands nearby as a C&LE freight line crosses in Rocky River out of Cleveland in 1936. (Courtesy Willis McCaleb collection.)

Cincinnati actually wasn't hit as hard as the rest of the country during the Depression, thanks in part to two major construction projects, which had been designed and funded before the stock market crash. Construction downtown of the Carew Tower office building and the adjoining St. Nicholas Hotel (the latter would later be renamed the Netherland Plaza) kept hundreds of Cincinnatians working in 1929 and 1930. Also begun in 1929 was construction of Union Terminal, which kept thousands more working through 1933. Built at a cost of $41 million, it was the first railroad terminal in the United States designed to allow all competing railroads to share one terminal facility. (Photography by Suzanne Fleming.)

In 1933, the extra-wide "Twin Coach" shared streets with regular buses, streetcars, and automobiles. (Courtesy Phil Lind collection.)

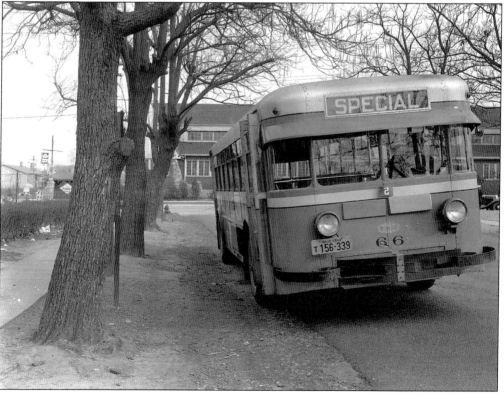

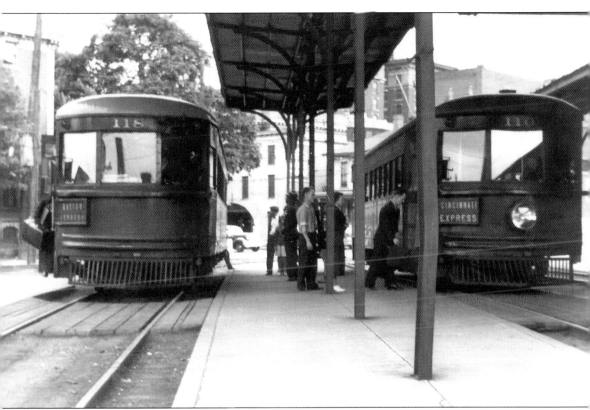

Passengers board two C&LE Red Devils at the Springfield Station, c. 1937. The 1930s would prove to be a momentous decade for the interurbans, too. The traction companies were headed into oblivion because they could no longer compete with the privately owned automobiles and interstate bus service. As more and more interurbans went out of business, hundreds of miles of track and wire were sold to scrap companies, which dismantled everything and sent it all to be recycled. In 1937, many of the C&LE's obsolete passenger cars were burned, dismantled or sold outright, including the old luxurious parlor cars, which were boarded up and sold. Many wound up in farmers' fields serving as storage sheds and chicken coops. (Courtesy Earl Clark collection.)

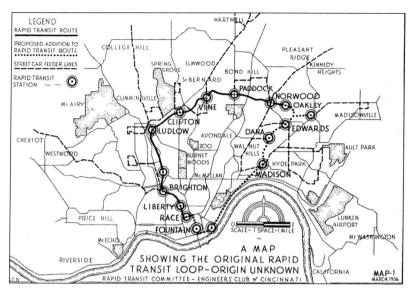

In 1936, the Engineers' Club examined the right-of-way and improvements made in the rapid transit property, consulted Frank Raschig, who was Chief Engineer during the original subway project, and studied the professional reports made for the city during the previous 18 years. They did not offer a definite solution; instead, they offered "lines of thought which we believe those in final responsibility for its solution must pursue before the correct solution of the important major problem of the general good is reached." (Courtesy City of Cincinnati.)

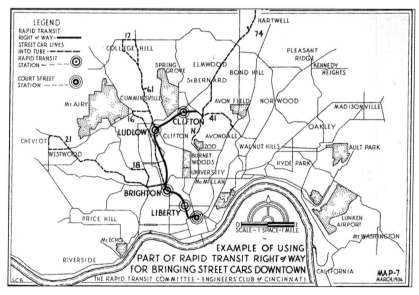

The resulting report found several possible solutions to the rapid transit issue, divided into two categories: transportation to and from the downtown area, and transportation within the downtown area. Transportation to the downtown area solutions included a completed rapid transit system based on the plans already made, a private right-of-way for trolley coaches or streetcars, and the use of existing rights-of-way as cross-town highways. (Courtesy City of Cincinnati.)

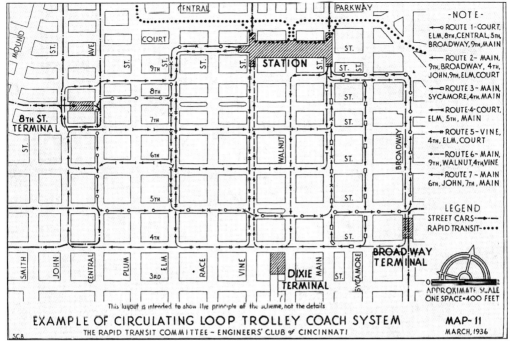

EXAMPLE OF CIRCULATING LOOP TROLLEY COACH SYSTEM — MAP-11

THE RAPID TRANSIT COMMITTEE ~ ENGINEERS' CLUB of CINCINNATI — MARCH, 1936

The transportation within the downtown area solutions included a subway system, a surface line plan, and a circulating loop plan. In that final plan, all streetcars and bus lines would be barred from the downtown business district. The driving and parking of private automobiles would be prohibited on certain streets, and even stopping would be forbidden in congested areas. Also, all mass transit vehicles would terminate at only four terminal stations, and would essentially act as "glorified taxicabs." (Courtesy City of Cincinnati.)

The Engineers detailed ways to coordinate the downtown loops with the suburbs. (Courtesy City of Cincinnati.)

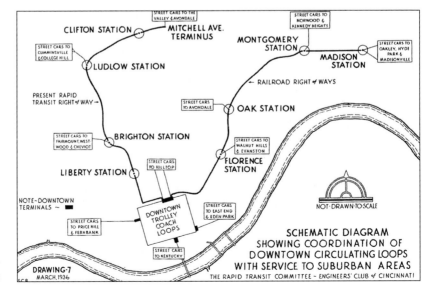

SCHEMATIC DIAGRAM SHOWING COORDINATION OF DOWNTOWN CIRCULATING LOOPS WITH SERVICE TO SUBURBAN AREAS

THE RAPID TRANSIT COMMITTEE of CINCINNATI

87

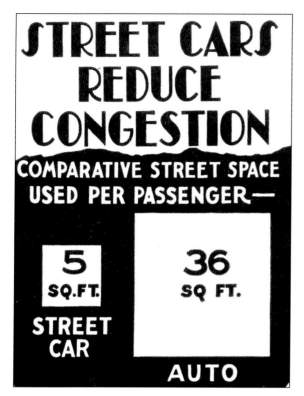

STREET CARS REDUCE CONGESTION

COMPARATIVE STREET SPACE USED PER PASSENGER—

| 5 SQ.FT. STREET CAR | 36 SQ FT. AUTO |

The circulating loop plan would bring 85 percent of the streetcars that ran downtown into a central station under Fountain Square; the remainder would come within one block of that station on the surface. The plan focused on the building of an additional subway loop in the downtown area in order to take the streetcars off the streets and provide for faster operation. This new subway loop would be built under Race, Fifth, and Main Streets, connecting with the one underneath Central Parkway. Five total stations would be built with surface connections. They would be located at Central Parkway and Main Street, Seventh and Main, Fountain Square, Seventh and Race, and at Race Street and Central Parkway. This simple chart demonstrates how little space a passenger uses in a streetcar. (Courtesy City of Cincinnati.)

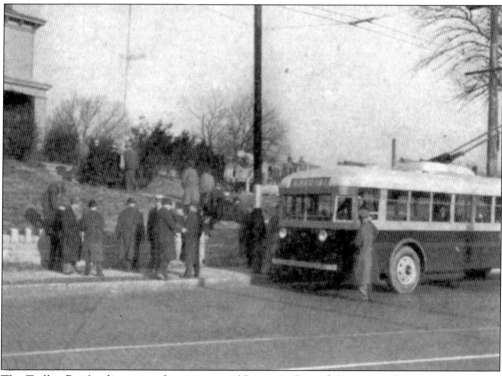

The Trolley Bus loading up with passengers. (Courtesy City of Cincinnati.)

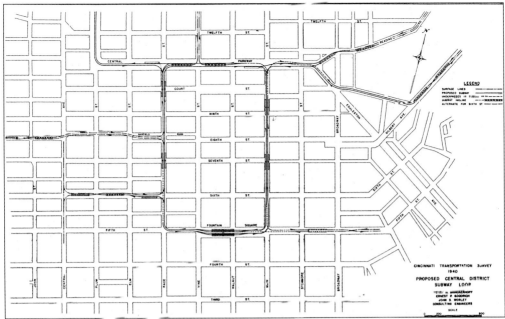

Like the previous reports in 1936, the 1940 traffic survey report recommended removal of all streetcars, trolley buses, and possibly motor buses from the streets by extending the original subway from Central Parkway south on Race Street, east on Fifth Street and north on Main Street back to Central Parkway. The city thus could develop a central traffic district bound by Plum Street, Third Street, Broadway, and Central Parkway, within which a complete system of one-way streets would be incorporated. The loop would cut ten minutes from the running time of most car lines, reduce congestion and increase traffic safety in the business area. (Courtesy City of Cincinnati.)

The consultants specified a "shallow" type of subway, one that was just below the level of the street, so as to minimize step-climbing for passengers. They proposed car entrances between Broadway and Sycamore, a connection to Reading Road with a portal just beyond the intersection of Eggleston Avenue, an entrance from Gilbert Avenue just east of the viaduct, and an entrance on Vine

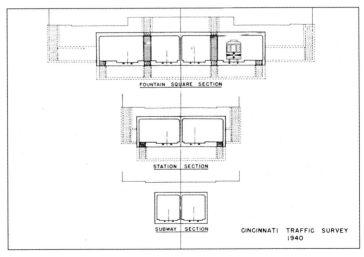

Street above the Parkway. "By this arrangement," they said, it will be possible to introduce lines from practically every section of the city into the terminal subway loop." The initial operation of the new subway loop would have to be limited to streetcars and trolley buses because of the additional $2 million ventilation cost for gasoline buses. Alternatives included an elevated train and widening streets to create a surface loop. (Courtesy City of Cincinnati.)

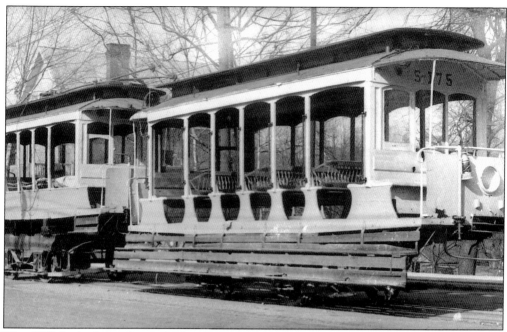

The CSR built these elevated "flood cars" to transport passengers through flooded regions during the 1937 Flood. (Courtesy Earl Clark collection.)

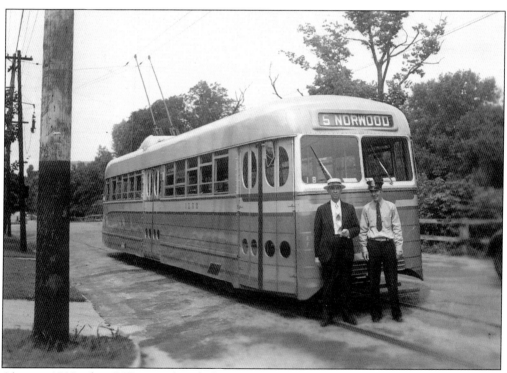

Also in 1937, the CSR introduced the new "Brilliner" car—the new modern streetcar. (Courtesy Earl Clark collection.)

Seven

WORLD WAR II
AND THE SUBWAY

"Don't you know there's a war on?" Such was the cry often heard in the effort to conserve, recycle, and ration. Practically every common item used by consumers, including all food items, clothing and gasoline, had to be suddenly portioned out so American soldiers could keep fighting.

Not only was rationing important to conserve products for the soldiers overseas, but now, for a small profit or for no money at all, Americans were urged to recycle anything that could be turned into products which could aid the war effort. Movie theaters held scrap iron and scrap paper matinees, where children could enter with donations of scrap material. Salvage officials sent trucks into residential neighborhoods and enlisted the aid of the Boy Scouts to gather iron, copper, brass, aluminum, and rubber. Scrap paper was used to make packing material for food rations, blood plasma, and ammunition so citizens were encouraged to clean out old files and turn in scrap paper from basements and attics. Due to the national shortage of shellac, record-buyers found it necessary to bring in an old record when buying a new one. Scrap drives were held to collect old records, thereby eliminating many future collector items.

America was a changed nation; a nation bent on winning the war. Patriotism never ran higher; Cincinnati was a city caught up in the American war effort. Local factories that previously produced regular consumer goods were now war factories with government contracts. Other businesses that could not produce war materials closed their doors for good.

Cincinnati's Fashion Frocks switched from sewing ladies' dresses to sewing parachutes for the military. Procter and Gamble continued producing consumer goods, but had to cut down the production of many of its household items to meet wartime restrictions and shortages. The company had to replace Crisco shortening's familiar metal can with a glass jar to avoid stopping or limiting the production of the shortening. Other companies used P&G's products, such as soap, to process fabric for uniforms and cloth equipment, to prepare metal for plating or painting, and as lubricants in metalworking. Mosler Safe stayed in business and made armor plate and tank turrets. Since not enough metal was available for Cincinnati Air Conditioning to produce their products, they built meat lockers, for which metal was allowed, to help stretch the national food supply. Rookwood Pottery in Mt. Adams produced wooden water pipes in lieu of ceramic goods, and the Progress Lithographing Company left the printing trade and installed machine tools for use in metalworking.

Many of the city's men were off fighting the war, and factories experienced a shortage of workers. As a result, women joined the factory workforce and helped keep the companies cranking out war machinery and consumer goods, giving birth to the sobriquet "Rosie the Riveter." A housewife who just a few months before may have been ironing shirts, now was pounding iron and riveting engines for B-29s at the Wright Aeronautical Corporation plant in Lockland. Teams of women and men ran the assembly lines in Cincinnati's war plants and put together machines that would help America win the war in Europe.

All Cincinnatians were encouraged to "do their part" to help win the war. For instance, the author's late grandfather Charles Singer served as an air raid warden in Mariemont during the war. He would drive his car through the town's neighborhoods during blackout drills and alert residents to turn off the lights in their homes. These drills would help people prepare for a real air raid during which enemy squadrons would seek out key cities to bomb.

"Victory" was the watchword for the American public. Due to shortages of fresh vegetables, Cincinnatians were urged to plant backyard "Victory gardens" in which they could grow and can their own vegetables. Crisco introduced recipes for "Victory cakes" to homemakers which used less sugar than regular cakes. "Victory Car Clubs" took carpoolers to work cutting down on gas consumption and tire wear.

Businesses started "staggering" employees' workdays to help cut down on automobile use. A major benefit of this program was improved streetcar seating because the streetcars weren't so crowded during rush hour times. And as time went on, the Cincinnati Street Railway Company saw booming business because of tire and gasoline rationing, peaking at almost a half-million rides on one day in December 1944. However, federal limits on the use of buses and on the production of new streetcars and track made service expansion difficult. The company showed its support for the war effort by issuing Sunday passes with illustrations that urged riders invest in war bonds, to volunteer at the Red Cross, and other necessary duties. They also refurbished fifty older streetcars that previously had been retired, and painted patriotic slogans on others.

In light of the world war, the Queen City set aside all rapid transit plans. But the city did still have unused subway tunnels, which might be useful for *something*. In 1942, when the possibility existed that the enemy might attack Cincinnati, City Manager Sherrill, who also served as civilian defense coordinator, suggested that the subway tunnels be converted into an air raid shelter. His idea was not implemented, though.

The next year, in November of 1943, a local business owner thought the tubes could be potential assets for the city. Mr. Henry A. Lange, who owned the Hal Manufacturing Company on Sixth Street, was convinced that the subway tunnels could be of much greater value to the city as an underground storage facility for the army, rather than a rapid transit subway. He suggested leasing the subway "for a great concentration depot for storage of all types of products and materials needed for the war effort." He said one side of the subway could be used for storage, and the other for transportation. Items which could be stored in the subway and used for the war included munitions, airplane motors, shells, food and farm products, and secret weapons.

Although nothing emerged from Lange's proposal, in December of that year, Attorney Clarence Hallman, who represented himself and a group of companies along Central Parkway, wished to lease the subway for ten years as an industrial transportation and storage system, and turn it back to the city after the lease ended. This plan would aid the war effort by saving tires, gas and labor.

The subway could serve a large variety of industries if it were leased for storage. For instance, breweries could use it for cold storage of vast quantities of grains and beer, and farming interests for cold storage of grains and poultry, eggs, fruits, and vegetables. And not only could Cincinnati use the storage facilities, but surplus supplies from other states could be kept there as well.

Traffic Survey Director Laurent Lowenberg and Alphonse Riesenberg, vice chairman of the Transportation and Subway Committee, strongly objected to the storage proposal. They agreed that 1943 seemed "a very poor time to make a ten-year lease for mere storage purposes." Lowenberg called the suggestion practical, but cautioned the city that "it would be missing a great opportunity not to complete the subway for transportation." Riesenberg held the opinion that a ten-year lease for storage purposes would "sound the death knell for our subway project in our generation."

By May, 26 companies were cooperating in the project to lease the "Central Parkway Subway" for freight and delivery service. Among the concerns vitally interested in using the subway were French-Bauer Brothers, three breweries including the Burger Brewing Company, and P. Goldsmith Sons.

The companies regarded their plan as an essential part of postwar industrial development in Cincinnati. The industrial section in which they were situated would be drying up because of the lack of nearby railroad facilities. Because of that problem, some of them would have to move their operations closer to the railroad access if they wanted to expand. However, a number of vacant factory buildings in the district could be made useful again if railroad facilities could be brought to their doors via the subway tunnels.

The debate continued through June 13. Rutherford Cox, a Union Central Life Insurance Company executive who served as a member of the Finance Committee of the original Rapid Transit Commission in 1916, recalled that whether the city should use the subway for people or for freight was not a debatable issue twenty-eight years before. He pointed out that "we had the subway built to handle both passenger and freight traffic," observing that the subway was originally built to bring the interurban railroads into the heart of the city. "Because of the stubborn attitude of the [Cincinnati] Traction Company of that day," he said, "we did not have access to the rights-of-way to bring [all] interurban cars down into the business district. As a consequence, Cincinnati was losing large volumes of business to such cities as Dayton, Hamilton, Columbus and Indianapolis."

Cox said that the subway was recommended and approved to correct the problem. But by the time the tunnels were completed in 1926, the interurban systems already had begun succumbing to the automobile. Meanwhile, Cincinnati owned a subway designed to handle freight and passenger traffic carried by the now-fading interurban lines.

Even though the original Arnold Report stated emphatically that the subway was built to move both people and freight, Laurent Lowenberg still disagreed. "It would be a lot more difficult," he said, "to merge and integrate the movement of separate passenger and freight trains." The freight-handling facilities of the tube originally were based on the character of the interurban cars, which combined passengers and light freight. These cars differed physically from the freight train cars.

Clarence Hallman, however, would not give up. In June he announced that the companies would sell stock and spend a quarter of a million dollars of their own money to lay track, "without one cent of expense to the city," and to obtain three railroads: the Baltimore & Ohio, Big Four, and the Pennsylvania. The businesses purchasing stock would be permitted to have freight delivered directly to their plants in proportion to the stock they had purchased. Out of the stock sale, at least $15,000 a year would be paid to the city for rent.

And Alphonse Riesenberg said no, no, no. The plan would set back use of the subway for mass transportation ten years, he said. He wanted to support a bond issue of $17 million to condition the subway for its intended purpose: passenger traffic only.

Only a new engineering study could determine whether the subway could be used for both freight and passenger traffic. And since the subway tunnels were built to admit interurban—and not actual railroad cars—the larger type freight cars could not fit into the subway tunnel. Then another plan was revealed that could further complicate the proposal. The State Highway Department planned to build a new six-lane highway in Cincinnati that would go right through the old canal bed, which was currently the unused rapid transit right-of-way.

The Council's Public Utilities Committee was well aware of the interference that the new highway would create with the proposed freight service system right-of-way. And they realized, too, that railroad freight cars would not fit in the subway tunnels. Also, the companies, especially the breweries, determined that diesel exhaust could contaminate their product. So interest waned and the city forgot the idea. And thus another proposal was shot down, money and time was wasted, and a lot of people's hopes were dashed. But the story was not over yet; the war was to end soon and Cincinnati would not give up that dream of rapid transit.

On April 17, 1945, a public forum was called at the Netherland Plaza Hotel to discuss how Cincinnati's postwar future was linked with improved transportation. Walter Draper (president of the Cincinnati Street Railway Company) said that all possible uses of the partially completed subway were being considered in plans for expanding mass transportation. Due to the heavy wartime load, trolley and bus service couldn't be expected to return to normal immediately. There would be an interim period between the end of the war and a return to normal that would be used for rehabilitation or partial reconversion of plant and equipment. In other words, don't expect any miracles in public transportation after the war.

The next month, the war ended.

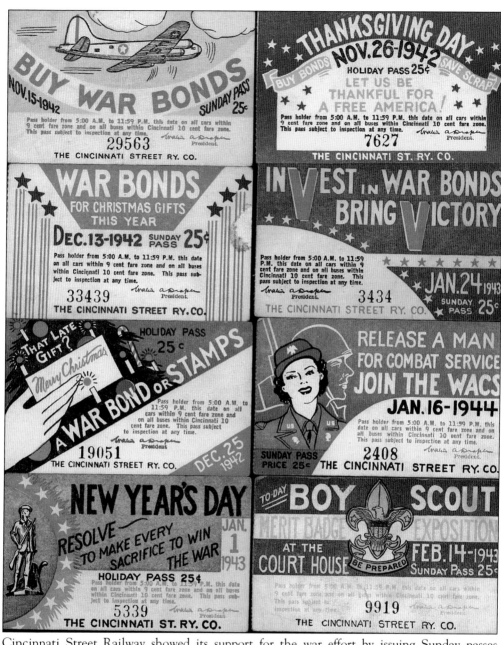

Cincinnati Street Railway showed its support for the war effort by issuing Sunday passes with illustrations that urged riders to invest in war bonds and to volunteer at the Red Cross. (Courtesy Phil Lind collection.)

Gathering scrap materials and rationing everyday goods became common; and when President Roosevelt authorized a nationwide campaign to encourage Americans to buy war bonds, Hamilton County raised more than one and a half billion dollars through the course of the war. (courtesy Cincinnati Historical Society Library.)

This "Observation Car" was built during World War II as a way to offer passengers a scenic ride through the Queen City. (Courtesy Earl Clark collection.)

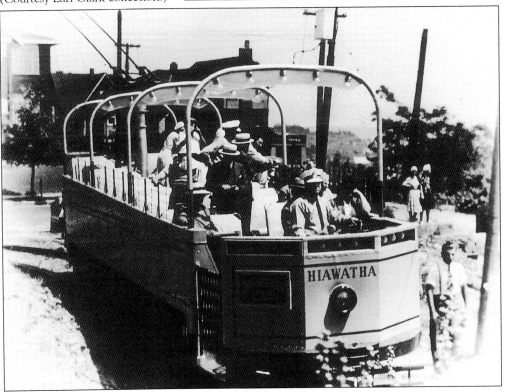

Whether they liked it or not, American citizens found themselves in the middle of a war being fought in distant lands. The war effort was national and involved everybody in all walks of life regardless of who they were or what they did. The major nationwide program of rationing that was instituted did not single out any American. The government's Office of Price Administration attempted to cap rising prices and to ration scarce supplies by establishing strict limits on such goods as sugar, coffee, meat, butter, tires, and gasoline. Local OPA boards issued ration books that contained stamps or coupons entitling consumers to purchase only specific amounts of such products. (Courtesy Cincinnati Historical Society Library.)

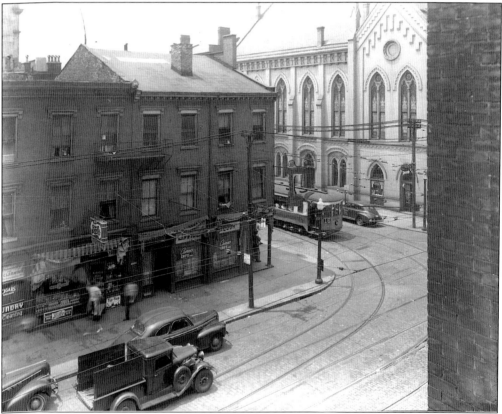

The decrease in traffic is still evident in June 1945, at Twelfth and Elm Streets. (Courtesy Phil Lind collection.)

Eight

THE LATE 1940S

THE END OF THE LINE

V-E Day—Victory in Europe—occurred on May 7, 1945. The Allies had defeated Italy and now Germany surrendered. Hitler's reign of terror ended, and America was victorious. Crowds of teenagers, servicemen and working adults engulfed Fountain Square, singing and celebrating all through the evening.

But the job wasn't finished yet. On August 6 and 9, the United States dropped two atomic bombs on Japan, and President Truman announced Japan's surrender at 6:02 P.M. Tuesday, August 14, 1945. The war was over.

> More than a victory of arms . . . a victory of one way of life over another . . . a victory of an ideal founded on the rights of the common man, on the dignity of the human being, and on the conception of the state as the servant—not the master—of its people.

On August 15, the John Shillito Company, a major downtown department store, took out a full-page ad in *The Cincinnati Post* and filled the page with this stirring quotation to celebrate the victory of America. Euphoria swept through Greater Cincinnati. The *Post* described the scene as "the ear-splittingest celebration of all time. It was a horn-blowing, bell-ringing, drum-beating, cheering grandpappy of celebrating."

Nightclubs and cafes closed their doors within an hour of the victory announcement and businesses all around the Queen City took both Wednesday and Thursday off. By presidential proclamation, Wednesday was a holiday, although not an official one. Most food stores closed on Wednesday but re-opened Thursday. Also, all liquor stores, leading department stores and major industries, including Procter and Gamble, closed through Thursday. Most restaurants closed down, but lines at the few eateries that remained open stretched out the doors. The restaurant closures accounted for the many house parties that roared on until the early morning hours. Churches and synagogues were jammed with thousands Wednesday night.

The *Post* reported Wednesday evening that the rationing of gasoline was immediately lifted, and "with shouts of exultation . . . gas-starved Cincinnatians . . . leaped into their autos [and] headed for the nearest filling station. In a trice, stations open for business were swamped. The long forgotten phrase 'fill 'er up' resounded the length and breadth of the driveways." Some gas stations had not yet heard the announcement and at first demanded ration coupons. Motorists happily handed over all their coupons and filled their tanks; gas stations didn't complain, most reporting a plentiful supply on hand.

Although rationing had been lifted from all petroleum-related products, it temporarily continued on automobiles, shoes, beef, pork, sugar, fats and oils, and dairy products. There were, however, plenty of processed foods, cereals, and tires, but tires would not be "pre-war" quality right away. And in time for Christmas delivery, 2.5 million radios would be manufactured by the end of the year.

Servicemen started returning home, anxious to resume and rebuild their civilian lives. Many veterans were disappointed with their new civilian lives. Disillusionment set in because just a couple of months before they might have been respected and important leaders in their platoons, but now they worked in subservient positions in offices and as laborers. Many others could not easily make the transition from the brutality of war to everyday civilian life, and had become different people from those whom their wives and families remembered. Still other fresh war veterans enrolled in college to try to build new futures for

themselves. Housing shortages created a boom in postwar tract-house developments.

At last, for every citizen in America the war was over and life could go on. In the Queen City, this meant, in the minds of many, that the subway project could be renewed.

Traffic congestion suddenly worsened with the return of veterans and gasoline. So once again the narrow downtown streets could not handle the automobiles, streetcars, buses and pedestrians that jammed the streets and slowed traffic. The city demolished buildings and built parking garages and lots to clear congested streets of parked cars. On January 2, 1946, the *Enquirer* reported that Cincinnati was handicapped by "unusually narrow streets and a very concentrated shopping district and office building area" and believed that the city should keep in mind the possibility of putting streetcars and trolley buses underground. "Costly as it may seem," the paper said, "it is a practical alternative to the widening of downtown streets."

On January 2, the Master Plan Division presented a preliminary study of the city's public transit facilities. The Master Plan was going to be Cincinnati's postwar improvement concept that addressed every aspect of urban life. The plan offered two preliminary solutions to transit problems. One was the rerouting of public transit vehicles on downtown streets including making all downtown streets one-way during rush hour, and the other was the construction of a subway. The subway project tentatively would cost $25 million and involved extending the subway along Central Parkway to loop through the downtown district under Race, Fifth, and Main streets. The new proposal reduced the full length of the downtown tubes, and thus costs, and also considered expressways proposed since 1940.

Three months later, in early April, the 26 companies who had shown interest in leasing the subway tubes renewed their interest in the plan to convert the subway into railway freight facilities. This time Attorney Charles P. Taft represented them; they asked for approval of an ordinance that would authorize the City Manager to advertise bids for leasing of the subway facility. Taft assured that the plan would not interfere with any future plans to use the tube for mass transportation. The ordinance was passed on May 1 of that year.

In the fall of 1946, the City Council's Finance Committee approved the application to use the subway as a freight line. A clause was added that permitted abandonment of the project if the International Commerce Commission did not approve a ten-year amortization plan. Cincinnati would be guaranteed approximately $36,000 a year in rent for the unused tubes if the public voted for the lease.

Charles Taft was pretty happy with the decision. "Thar's gold in that thar subway—for the taxpayers," he said on October 18 in an address to the Cincinnati Car Riders Association. After explaining the minimum rental return of $36,000, he said, "the return may go much higher as business develops, for the returns are based on the number of cars using the freight line." The city, though, reserved the right to order the leasing company to remove its tracks and restore the subway to its original condition.

The Cincinnati Post stated on November 1 that the subway was the "city's most celebrated 'white elephant,'" but an annual rental of $36,000 would mean that the famous "hole in the ground" could be put to good use by Cincinnati industries. "We have had survey after survey" the newspaper said, "on what the city could do with the subway, but this is our first chance actually to DO SOMETHING." The *Post* recommended that the people of Cincinnati "seize this opportunity to DO SOMETHING with the subway by voting in favor of the franchise."

And "do something" they did: the franchise was passed and the voters authorized the issuance of a franchise for the use of the section of subway between Plum Street and the Ludlow Avenue viaduct. The Parkway Industrial Railroad Company was negotiating with the city for the franchise, and would have to reach an agreement with the B&O Railroad on the handling of freight moving in and out of the subway.

And then came the end. In mid-December, 1947, Professor Ernest Pickering, chairman of the City Planning Commission, publicly announced that "the uncompleted [subway] project probably will not be recommended for future development in the Master Plan transit report."

Pickering and the rest of the City Planning Commission would soon release the Master Plan Report that would describe the decision to abandon any and all hope of ever using the subway tubes for rapid transit. The Commission had decided that the best remedy for the traffic problems in Cincinnati lay in surface improvements. The modern trends pointed toward expressways and buses. The proposed Mill Creek Expressway, which later would be named Interstate Route 75, duplicated a major portion of the subway route. Also, the tubes that lay beneath Central Parkway were just not large enough for buses. At this point in 1947, buses were more numerous in the city than streetcars.

It seemed, then, that the dream of the *Graphic* was on its way to extinction.

On November 20, 1948, an editorial in *The Cincinnati Enquirer* reported that after a year, opinion about the subway was still the same. "The whole concept of mass transportation has changed since the subway

was begun," the paper said, "and if the project were completed now it would do very little to solve the basic problems to be faced in this year and coming years." City buses were to use the expressways to make real savings in route times and federal and state aid was always available to help with improvements to the expressways. The newspaper said that maybe, sometime in the future, the subway would fit in with transportation needs of a "larger" city, but in 1948 "it does not merit priority . . . and present discussion therefore seems pointless."

Oddly enough, though, there were nay-sayers who still believed Cincinnati needed to extend the subway into a downtown loop. But, as the *Enquirer* said a month later on December 26, "however well-intentioned, these proposals ignore the plain facts of life." Cincinnati, the paper stated, just wasn't big enough to warrant a subway. "If Cincinnati had five times its present population and had that population compressed into its present area, it still would not have enough people to warrant building of a modern subway. . . ." And based on the experiences of some other cities, subways were not always the best answer to urban local transportation problems of the future.

In 1948 Chicago had a population of four million and five miles of subway with plans to build four miles more. But Chicago's civic leaders were leaning toward expressways and ultimately were to abandon their ambitious plans for a vast subway network. Detroit had two million people and also had considered a subway system, but laid it aside for superhighways; the subway scheme proved to be too expensive for Detroit. New York, however, was unlike any other city in the country; with eight million people, it just could not operate without its 270 miles of subway system.

But Cincinnati? Not really. "As the experience of other cities plainly shows," the *Enquirer* said, "the expressway program will come much closer than the subway to doing the whole job that needs desperately to be done." The newspaper advised forgetting the impractical dream of a subway, and trying to get on with the expressway plan. "We cannot make this a modern, efficient city by pouring new millions into an obsolescent form of urban transit."

The Master Plan definitely did not include plans for the subway; expressways instead were what the planners wanted. But just because the 1940s did not yield a futuristic rapid transit system, it didn't mean that hopefuls were giving up. The 1950s were right around the corner, poised for another decade of "great ideas," political change, and turmoil.

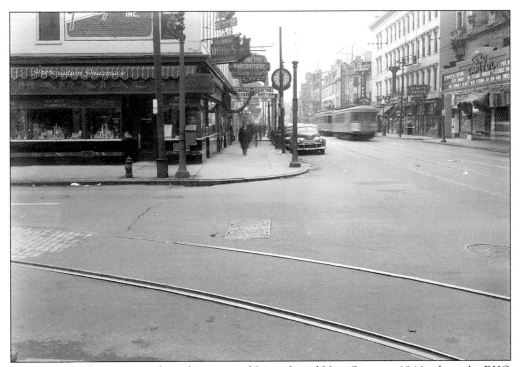

A streetcar is whizzing away from the corner of Seventh and Vine Street in 1946, where the RKO theater is showing Hedy Lamarr in "The Strange Woman." (Courtesy Phil Lind collection.)

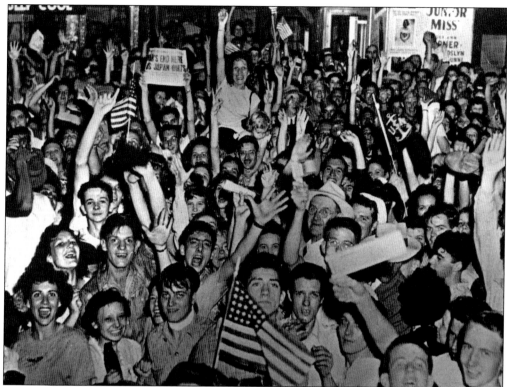

A crowd of 15,000 gathered at Fountain Square, blowing horns, singing and shouting under a shower of an estimated 200 tons of paper tossed from office windows above. Twenty downtown blocks were cleared of automobiles and turned over to the jostling, whistling, and yelling crowds. (Courtesy Cincinnati Historical Society Library.)

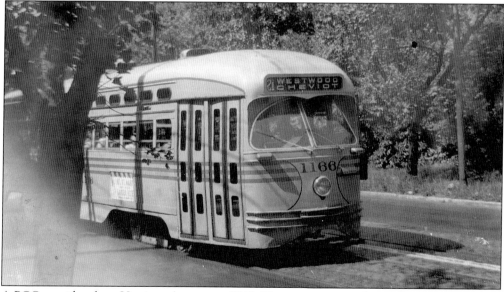

A PCC car rides along Harrison Avenue, c. 1947. The new car sported a modern, art-deco style. (Courtesy Earl Clark collection.)

Nine

THE 1950S

WATER MAIN AND
A BELT SUBWAY

The mere mention of the 1950s conjures many sentimental memories: big cars with fins, weekend matinees, the Golden Age of television, and the baby boom. Also, memories of times much less pleasant survive from the '50s: American soldiers fighting in the Korean War, and the possibility of nuclear attack. The 1950s were called America's "Innocent Age," characterized by TV shows like "Captain Video," "Kukla Fran and Ollie," and "Leave it to the Girls" whose schedules the papers carried daily. In the comic strips, the 1950 reader followed the daily exploits of *Blondie, Barney Google and Snuffy Smith, Rip Kirby,* the brand new *Peanuts,* and the new college strip *Beetle Bailey.* Popular movies that year included Walt Disney's *Cinderella, the Daughter of Rosie O'Grady* presented in Technicolor, and *Harvey* starring Jimmy Stewart.

For modern home entertainment, General Electric unveiled its "complete home theater," that contained a "black daylite television" with a sixteen inch rectangular tube, an AM-FM radio, *plus* a three-speed automatic phonograph in a genuine mahogany-veneered cabinet with full-length doors. All this for only $499.95, available at Chas. F. Lenhart on 125 E. McMicken Avenue. Interest in Frank Sinatra and Perry Como and big band swing music was waning among young people; they instead favored the new sounds of rock and roll that started hitting the AM airwaves in 1951. Cleveland disc jockey Alan Freed struck gold when he began playing rhythm and blues records by the Clovers, the Dominoes and the Midnighters on white radio and attracted a whole new audience for the music.

The new post-war America delivered affordable automobiles to thousands of car-hungry motorists. In 1950 the Walter E. Schott Company on Gilbert Avenue sold new Willys station wagons and jeepsters, boasting a "sensational Hurricane engine" which promised 7:4 compression. All area Buick retailers featured the new 1950 Buick Roadmasters, which delivered a smooth "unruffled" ride because that car company gave "every Buick four of the soft, gentle coil springs practically all cars use on front wheels only."

The proliferation of automobiles brought Howard Johnson restaurants, travel excursions along Route 66 and the Pennsylvania Turnpike, car-hop restaurants and drive-in theaters. The population of the United States had doubled since 1900, and the baby boom had driven thousands of middle-class Americans into Suburbia's postwar tract-house developments. The country had picked itself back up since the war ended and Americans were happy again.

The people of Cincinnati were no exception as careers took off and families moved to the suburbs. Streetcars still rolled through the streets carrying passengers downtown and to the suburbs. And the dream of rapid transit was still alive in the Queen City, but not in the Master Plan. However, there was hope that that would change. In May 1950, the Fourth Street Area Merchants' Association, headed by Executive Vice President Joseph Barg, suggested that the City Planning Commission incorporate a rapid transit line in the proposed northeast expressway.

Barg believed that the building of expressways would not solve the majority of traffic concerns, and that bus transportation would not be any faster on expressways than on the present streets. "Whether you operate a jet-propelled bus or a two-hundred passenger bus," he said, "these vehicles alone cannot give swift, efficient, and above all, safe rapid transit, because no vehicle can move faster than the other vehicles around it."

Barg advocated that instead of running city buses on expressways, a rapid transit system by rail in the center strip of the expressways could run on its own right-of-way. He suggested that the Street Railway Company's PCC cars could be used on the new rails.

During 1950, the threat of enemy attacks held a dark cloud over the United States. Cities across the country were building air raid shelters, and Ohio Congressman Charles H. Elston told Washington on December 21 that Cincinnati's unused subway would make an ideal air raid shelter. This attention caused Cincinnatians to realize that the old subway could save their lives if a flight of enemy bombers ever attacked the city.

Before the war, the tunnel had been suggested for use as a bomb shelter, but nothing had come of it. Now the city wanted to determine the actual cost of converting the subway to an air raid shelter. As part of the conversion outlay, a forced ventilation system would be required, leaks needed to be stopped and lighting arranged. The tunnel might be worth converting to a shelter if it could hold enough people during an emergency.

Aside from air raid shelters and the rejuvenation of interest in rapid transit, a major change was taking place with the Street Railway Company. On April 17, 1951, Morris Edwards, president of the company, announced that after April 28, the conversion of all streetcar routes to motor coaches or trolley buses would be completed. Also, the bus fare would increase to fifteen cents for adults, and to seven and-a-half cents for tickets or eight cents cash for children under ten.

At 6:10 a.m. on April 29, 1951, the last streetcar pulled into its car house, and track-bound vehicles forever disappeared from the streets. Thus ended another era in Cincinnati's history of rail transportation, and the Queen City once again took steps to march into the future. Approximately $15 million had been spent in the reconversion program, and all but a small percentage of the buses currently in operation had been acquired since the war. The fleet now consisted of 384 gasoline and diesel buses and 308 trolley buses.

The subway tunnels often presented a unique, but quite illegal, experience for urban adventurers. In one instance, following a "spooky" Wednesday afternoon in April, 1954, three teenage girls agreed that they would never go "cave exploring" again. During recess from their school, they found a big hole near Colerain Avenue with a broken gate with a tunnel just beyond. They squeezed through and started traversing the cave. (This entrance has long since been demolished to make way for road projects.) Once the girls started, there was no turning back and "then we went around a curve and could see light up ahead. We thought it was the end of the cave and we went up there."

Another girl added, "there were a lot of little side passages. We went in those, too. Then nobody knew how to get back out." After deciding they were lost, they tried climbing ladders and poking sticks through gratings and yelling for help. Nobody paid attention. Eventually the teenagers got out at Vine Street and Central Parkway, after walking for over two miles. They climbed to a grating and shouted to a little boy who called his mother, who called neighbors, who called the police. A policeman arrived, pulled off the grate and rescued the girls. The three were "frightened to death," but none the worse for their experience.

As the three teenage girls discovered from firsthand, the subway tunnels still lay beneath the streets of the Queen City. The "white elephant" sat waiting to be used for its intended purpose—or any purpose at all.

Then, two years later, the City Council announced on April 13, 1956 that they had found a practical use for its elephant. They approved a measure to let the city lay a 48-inch water main in the subway tubes. Water Works Superintendent Carl Eberling told Council that the city would save almost $300,000 on construction and excavation costs and thus avoid digging up streets and impeding traffic. In a strange twist, the subway finally would be serving its purpose; but instead of carrying passengers it would be carrying water, augmenting the supply to the Western Hills station on Queen City Avenue.

In case the city ever decided to use the tunnels for their actual intended purpose, the city had an escape clause. Ordinance No. 154-1956 stated that the Water Works could lay the water main in the unused subway tunnel, but "in the event said section of the rapid transit subway is, at some future date, needed for rapid transit purposes, the Water Works shall remove said main at its sole cost." The city still thought that rapid transit existed as a remote possibility.

During the winter of 1958, another new idea surfaced to help move Cincinnatians around downtown. The Mass Transportation Committee of the Property Owners Association announced on Christmas Eve that they polled public officials and transit authorities in fifteen cities to find out how they were tackling their transit problems. The committee found that the problem was just as severe in cities with municipal ownership as in those with privately-owned transit companies like Cincinnati's.

For instance, Pennsylvania Railroad officials believed that Pittsburgh's problems could be solved

by leasing trackage from the railroads in Pittsburgh's outlying areas and using them for rapid transit. Chicago developed a new system of using the center strip of expressways for rapid transit trackage, but the engineering of Cincinnati's Mill Creek Expressway would not accommodate such usage.

Other ideas considered by the committee included monorail, but they disregarded the plan because it had "not proved to be efficient and . . . in general its disadvantages outweighed its advantages." They temporarily tried using restricted lanes for buses on Fourth Street, and found that it "speeds up traffic and reduces congestion." City Traffic Engineer George Howie held an opposite position. He thought the experiment slowed traffic and cut street carrying capacity. The committee also discussed the "carveyor" system; it appeared to have a "definite place in our future planning."

By July 1961, General Electric corporately was pushing for rapid transit, having taken upon itself as a national civic duty the need to discover a way to untangle the nation's urban traffic jam. GE believed that businesspeople should take an active interest in four crisis areas: urban renewal, water shortage, air pollution, and transportation—the key factor in the development of major urban areas. They said that expressways were a fine answer, "but after that, then what?"

GE had been supporting a rapid transit campaign for at least three years because it sold heavy electric equipment, controls, and motors for rapid transit use. But the company emphasized that "even if we never sell a single motor, anything we can do to help a community recognize the true problem—maintaining a good, fluid, successful community, we will benefit." After all, they said, "we can't sell refrigerators or anything else in cities that are sick."

GE held an ulterior motive to its stance on rapid transit. In 1948, American families spent six percent of their income on transportation. By 1961, the figure was up to between 12 and 15 percent, leaving a good deal less for them to spend on other things, such as GE products. The company felt that affordable rapid transit might reverse that trend. And although GE wasn't supporting *only* rapid transit, the company did feel that eventually it would be the answer.

The controversial expressways, including the Mill Creek Expressway (I-75) and the Norwood Lateral (562) were completed by 1962, both using portions of the original rapid transit right-of-way. Still, GE believed that Cincinnati needed rapid transit, but civic leaders did not share their belief.

The Queen City might have been facing traffic issues, but America was facing larger issues with a cold war with Russia, as it had been since the 1950s. Cincinnati was practicing what to do in case of nuclear attacks, and many buildings were constructing fallout shelters. But the Queen City lacked a large community fallout shelter that could be utilized by federal personnel, county and city government officials, and select citizens in the event of a disaster situation involving fallout.

As with the water main from a few years before, the "white elephant" came to the rescue again.

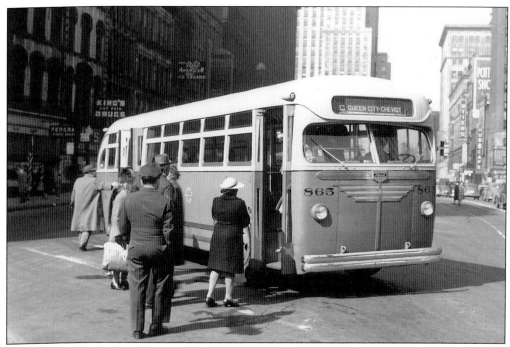

Passengers board the No. 865 bus downtown at Government Square in the early 1950s. (Courtesy Phil Lind collection.)

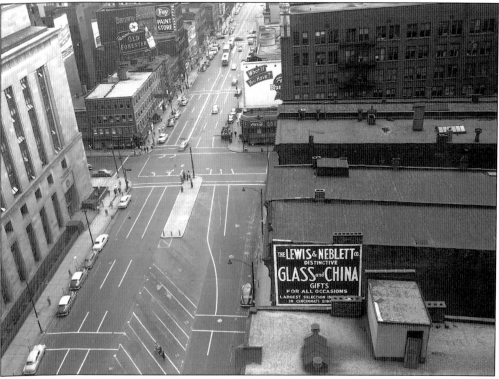

Government Square in is seen here from above in 1953. (Courtesy Phil Lind collection.)

In 1953 the Goodyear Tire and Rubber Company proposed a new, technologically-advanced public transit system that wasn't quite "rapid transit," but was close enough. "The Passenger Conveyor Belt for Cincinnati" promised a "modern subway system" for the Queen City. This was an "ultra-modern transportation method" that would virtually eliminate motor and pedestrian traffic congestion, serving as the heart of the city's present public transportation system. It would even eliminate the need for most on-street parking in the main business district. (Courtesy City of Cincinnati.)

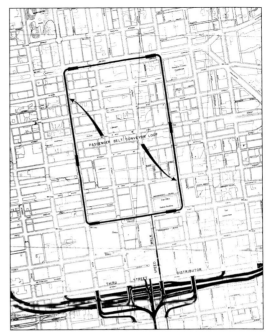

Goodyear suggested other uses for the Speedwalk. Modern airports could use the moving sidewalk for two-way transportation: passengers could walk while on the moving belt and increase their speed by 50 percent, or they could stand still on the belt while being carried through the airport. Another use for the Speedwalk was for large parking lots in suburban shopping malls. Shoppers needed an easy way to get from the parking lots to the stores, and Speedwalks could facilitate that need well. The Speedwalks could wind through the entire shopping mall so customers could shop the entire center quickly and easily. Speedwalks could also be installed in major sports facilities such as race tracks, football and baseball fields. (courtesy City of Cincinnati)

Along with the moving conveyor belt car system, there would be a moving passenger sidewalk under the Goodyear trade name, "Speedwalk," which would move at about a mile-and-a-half an hour. The Speedwalk would run through the stations to allow for quick and nonstop boarding of the cars. This scheme would eliminate waiting and platform congestion. (Courtesy City of Cincinnati.)

Goodyear's "Carveyor" was a continuously-moving belt on which small passenger subway cars rode. They would speed up in an "easy, fluid motion over a bank of accelerating rollers graduated up in relative speeds from half normal walking speed to fifteen miles per hour." There would be six two-way terminals with loading platforms from which passengers would board. Passengers could transfer from the moving loading-belt to cars by simply walking into the car of their choice and being seated. The equipment would never stop, and traffic would be maintained in a continuous flow, allowing no time for jams or crowd build-ups. (Courtesy City of Cincinnati.)

A typical passenger could travel over five blocks throughout the conveyor belt subway in less than six minutes "without being pushed, ruffled or hurried." They estimated that the belt subway system could be built for approximately 60 percent of the cost of installing a conventional subway. Operational costs of the belt subway were estimated at a figure 40 percent lower than those accrued in operating a train subway. Goodyear estimated that all the belt subway equipment, excluding excavation, would cost $5 million. The cost of moving all the underground utilities proved far too costly, though. (Courtesy City of Cincinnati.)

It's raining on 4th Street between Vine and Walnut Streets in this scene from the mid 1950s. (Courtesy Phil Lind collection.)

Passengers wait for more buses to arrive in Government Square in March 1960. (Courtesy Phil Lind collection.)

Ten

Nuclear War, Wine Cellars, and Other Schemes

In January 1962, Cincinnati decided to turn the Liberty Street subway station into a prototype community fallout shelter that could protect 500 people from wind carried fallout. The shelter was to extend a total of 500 feet beneath Central Parkway, with entrances through 8 doors set flush in the sidewalk at the northeast corner of Liberty Street and Central Parkway. Construction included replacement of concrete sidewalks, new entrances, new metal sidewalk doors, railings, concrete block partitions, heating and ventilation, benches, shelving, and toilet facilities. Also, the shelter would contain doors, showers, a pump-driven well, small kitchens with appliances, a diesel standby generator, filter rooms, first aid rooms with hospital equipment, two storage rooms, a small administrative control center, and decontamination showers "guarding" both sides of the entrance ramp.

Workers sealed off a 687-foot stretch of the subway with concrete blocks to isolate the shelter. The shelter would occupy part of one of the twin tubes along with the station (the other tube accommodated the water main). In the event of a disaster, no one would be able to get into the lower reaches of the shelter without passing, fully clothed, through decontamination showers. Since the bunkroom didn't contain enough cots, the 500 people staying there would have no other choice but to sleep on the rows of long, hard, 200 foot wooden benches.

Construction was scheduled to start April 26, and On November 11 the *Enquirer* announced that the shelter should be finished before December 25. Several situations plagued construction, though; most critical was the lack of water. The plan called for the digging of a well to furnish fresh water for the shelter, but finding it was impossible; it turned out that there was no water under that portion of Cincinnati. Federal authorities ended up stocking the shelter with large cans of water.

Vandalism was another problem. Mysteriously, vandals regularly broke into the shelter and smeared tar on furnishings, tossed equipment around, and walked off with batteries. Eventually an inspector discovered how the vandals gained entry. Construction of the southern end of the Mill Creek Expressway had gouged a hole into the shelter; vandals found it and went in. The hole was soon plugged.

Hamilton County Civil Defense needed at least three more weeks to paint signs, stock the shelter with supplies, organize shelter teams, hand out keys to authorized persons, wrap up the final details and clean the vandals' damage.

The fallout shelter was finished after Christmas and fully equipped for a nuclear emergency. It featured a wooden floor built on the concrete platform, fencing, ceiling lights, an office with a working telephone, cots, toilets, showers, and a stockpile of hundreds of Civil Defense canisters of sanitation accessories, metal tins of animal cracker-like biscuits, big cans for drinking water, and various other fallout necessities.

The Queen City was prepared for a nuclear war should it occur. Of course a war never came, but the fallout shelter was maintained by Hamilton County Civil Defense through the 1980s until the cold war ended. Later in the 1980s the shelter was abandoned and emptied of most of its contents. Currently the shelter remains, but almost all of the Civil Defense canisters are gone, and the ones that remain contain mostly garbage.

A couple of years after the fallout shelter was built, on December 10, 1965, the City Sinking Fund

would make the first of two final payments on the principal of the indebtedness incurred by the subway construction. When the final payments were made, a total of over $13 million ($13,019,982.45, to be precise) had been invested, and in 1966 the subway was finally paid off.

Concurrently, a local wine company thought it would be a good idea to make and store wine in the subway tunnels. In late December 1965, Meier's Wine Cellars Inc. of Silverton, Ohio, contacted City Hall about leasing the subway tunnels to store wine produced from vineyards they planned to grow in Cincinnati. Meier's believed that wine caves in the subway tunnels would make a nice attraction for visitors to Cincinnati. H.O. Sonneman, president of Meier's, visualized a wine cellar that included a complete bottling operation as a tourist attraction. Tourists never got their chance to see wine caves under Cincinnati, partially due to lack of proper building codes.

During 1966, post-war prosperity and extensive automobile assembly-line construction caused fewer and fewer people to ride city buses. In 1968, the Hamilton County Commissioners formed the Board of SORTA, the Southwest Ohio Regional Transit Authority. The owners of Cincinnati Transit, the operator of the city bus lines, struggled to cover rising costs with higher fares and caused ridership to decline.

The City purchased the assets of Cincinnati Transit and assigned the operation of the new, public system to SORTA. The new transit system started operations as the public city bus system, Queen City Metro. Ridership increased from 17 million passengers to 19 million as fares were cut from 60 cents to 25 cents, and with immediately improved services. Queen City Metro has continued its success to this day.

Even in the 1970s, the dream of any kind of new public transit still did not die. In May 1973, local realtor Albert Lane proposed an aerial tramway or monorail between Riverfront Stadium and Mt. Adams. Lane visualized both residents and visitors in Mt. Adams parking their cars in the facilities at the stadium and riding the tramway to the top of the hill.

That was, of course, just another idea.

In September 1974, a new idea surfaced that could have revolutionized downtown shopping in Cincinnati. A local interest, Nick Clooney Productions, wanted to lease the entire subway and turn it into an underground shopping district. They desired to commission local art students to paint the tunnels between Race and Brighton with artwork depicting the history of the city, sublease curio retail shops and boutiques, and install and operate a nightclub in the area with complete restaurant facilities. Nick Clooney, who was then president of Nick Clooney Productions, recalls that his interest in the subway tunnels dated back to his childhood. "I was fascinated by stories from my family that toll booths and passenger platforms were already in place. In doing features for TV, I learned the stories were true, though many of the areas were being used for civil defense storage at the time." The nightclub/retail project, originally his suggestion, "foundered quite early on the issue of insurance."

In December, Public Works Director Arthur Bird stated that the subway was not safe for any type of development and denied the request of Nick Clooney Productions to turn the tunnels into an Underground district.

Interest in the subway was renewed in spring of 1977, when OKI developed a mass transit plan in response to gasoline shortages. The plan called for a light rail system with runs from downtown to Western Hills, a line to Norwood, and a line across the Suspension Bridge to Fort Mitchell in Northern Kentucky. All three lines would merge near Riverfront Stadium, accessible to downtown stores and offices on foot. When the energy crisis passed, the need went away.

In 1981 WKRC-TV featured the history of the subway on the nightly program "PM Magazine." With the assistance of Public Works, producers at WKRC videotaped sections of the old subway tunnels for a special program. The piece, entitled "Subway to Nowhere," aired on Friday, August 22, 1981, and was well received. It later won a local Emmy Award, and many local viewers still remember that show.

In 1982, Cincinnati still looked toward the future with its eye on light rail. That year City Council adopted the "Cincinnati 2000 Plan," a template for downtown development covering the next two decades. The Cincinnati 2000 Plan, or the "Year 2000 Plan," said that any changes that took place in city development should go along with their template. This time, light rail and a subway system were included in the Year 2000 Plan as an option when no more downtown land was available for new parking garages.

A few years later, one of the more widely known ideas on how to use the subway tunnels was presented to Cincinnati. In early 1987, the Ohio Film Bureau wanted to encourage filmmakers throughout the country to consider filming in Cincinnati's subway. "It would be ideal for a film producer or director who has a script calling for subway scenes," said Eve Lapolla, manager of the Film Bureau. The Bureau obtained permission from City Hall and would eventually call itself the Greater Cincinnati/Northern Kentucky Film Commission. The location has been presented to many movie producers since, including the makers of *Batman Forever*, but the subway hasn't yet been used in a Hollywood feature film.

110

Another interesting subway usage idea came in August of 1989. The University of Cincinnati Department of Aerospace Engineering wanted to turn a part of the subway tunnels into a wind-tunnel research facility. UC's Dr. Peter Desimile, director of the Fluid Mechanics Lab and professor of aerospace engineering, said that the tunnels could be used for aerodynamics tests. He even had huge fans placed near the entrances to the tunnels where they would sit until the Ohio Department of Transportation and the Department of Natural Resources approved the wind tunnel. Nothing emerged, however, from the wind tunnel plan, and the massive fans in front of the tunnels by I-75 sat for five years until the city decided that they were becoming eyesores and needed to go. Many people today still remember seeing those fans sitting in front of the tunnels all that time.

The 1990s began with the government-mandated Clean Air Act, forcing major cities across the country to plan ways to cut down air pollution. This issue spurred Ohio's city and state officials to mandate regional standards for pollution control, as well as study new methods of modern mass transit systems. Throughout the 1990s, many such studies were conducted and many plans were thought out, reworked, and shelved, just like old times.

It wasn't until 2001 when planners presented a workable light rail scheme that included a run from downtown to Kings Island in Mason along I-71, and west to the airport. The plan even included utilizing the old subway tunnels and the creation of new, modern downtown streetcars. A small sales tax increase was put forth to the voters to decide, at long last, whether to embark on a thirty-year project to build a citywide modern light rail system in Cincinnati.

"Issue 7" was voted down on November 5, 2002, and once again, Cincinnati would not see a light rail system built in the Queen City. Taxpayers and voters of Cincinnati have made it clear that they support sales tax increases for sports arenas rather than a longer-lasting project that would greatly improve the socio-economic standing of the city. The main reason Issue 7 was voted down was due to the proposed increase in sales tax to help pay for the project. If the light rail ballot had come before the new stadiums, then it is likely that light rail would have been passed. Instead, Cincinnati would rather have new stadiums.

Only time will tell what's in store for Cincinnati's future. The city's suburbs continue to grow, and downtown life is slowly being revitalized with the building of new affordable townhouses in various sections of downtown. Main Street in Over-the-Rhine has undergone a radical change with a popular bar district, as well as new dot-coms and other businesses and affordable integrated housing. Vine Street, which has always been a district the city has been trying to change (containing dirty streets and abandoned buildings) is slowly seeing improvement. Improvements in the Queen City will take many years, but the likelihood of a light rail system ever being built during these years seems less likely every year.

Meanwhile, beneath Central Parkway, the subway waits. With changing times and attitudes, perhaps the city will use those tunnels sometime in the 21st century, for rapid transit or for something else. Even though a myriad of various schemes have been proposed and rejected in the seven decades following the subway construction, future dreamers will never stop dreaming. The existing subway is still a fine underground historic structure that is barely being used. It is hoped that someday modern Cincinnati will use those tunnels to benefit its people, possibly in ways that were never imagined before.

Some dreams never die; they just take new forms.

This water storage can from the fallout shelter, found at a downtown garage sale by the author, could be used first to store water, then after being emptied, could be used as a commode. (Courtesy the author's collection.)

Even the new air conditioned "Dreamliner" buses introduced in the early 1960s couldn't motivate commuters to start using buses more than expressways in their own cars. A parade of Dreamliner buses is driven through Fifth and Vine Streets downtown in May 1965. (Courtesy Phil Lind collection.)

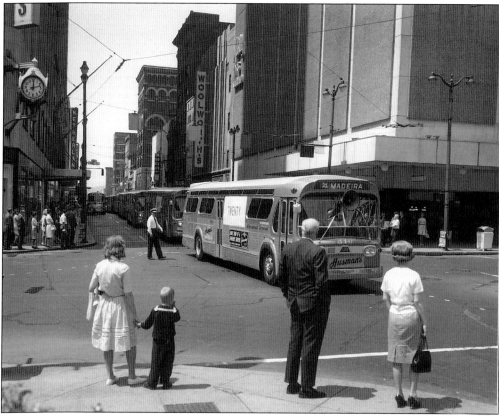

An early Queen City Metro bus sports a new paint job in 1973. (Courtesy Phil Lind collection.)

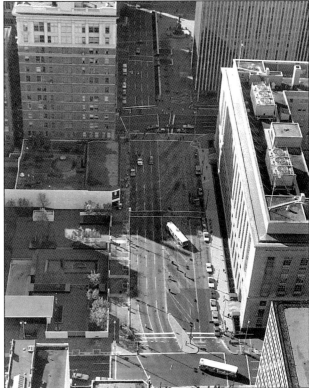

Buses navigate through light traffic at Government Square in 1975. (Courtesy Phil Lind collection.)

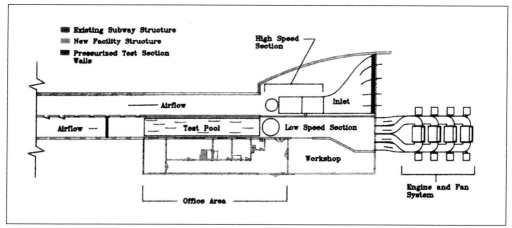

A basic diagram of the wind tunnel plan of 1989. The University of Cincinnati Department of Aerospace Engineering believed the subway tunnels could be used as a a wind-tunnel research facility. Huge fans were placed near the entrances to the tunnels where they sat until the Ohio Department of Transportation and the Department of Natural Resources approved the wind tunnel. As with so many other subway tunnel plans, nothing came of this one, and the massive fans in front of the tunnels were finally removed when the city decided that they were becoming eyesores. (Courtesy City of Cincinnati.)

A present day view of Central Parkway looking east from atop Court Street Center. How many are even aware of the empty subway tunnels lying below, and their long, storied history? Over-the-Rhine can be seen just to the left of Central Parkway. (Photography by Suzanne Fleming.)

Central Parkway looking north from atop Court Street Center. (Photography by Suzanne Fleming.)

"To the People of Cincinnati" is inscribed on the Tyler Davidson Fountain in Fountain Square. (Photography by Suzanne Fleming.)

AFTERWORD

On February 18, 1998, the author was able to do something that few Cincinnatians have been able to do legally: take a tour of the subway tunnels. Civil Engineer Technician John Luginbill and Engineer Steve Gressel included my photographer Suzanne Fleming and me on their yearly inspection tour of the subway tunnels.

Not much of the subway exists today. As a matter of fact, only about 2.2 miles of tunnels still lie beneath city streets. The longest segment is underneath Central Parkway, starting between Walnut and Main downtown. It continues northward near the Western Hills Viaduct adjacent to I-75 and ends at the arched doorways near Hopple Street, directly beneath the Parkway. Motorists on I-75 can see these portals from the interstate when the vegetation is low. Three underground stations remain at Race Street, Liberty, and Brighton, and no aboveground stations or bridges exist anymore.

A smaller portion, intended to be a short underground run that would go beneath a street, picks up just about a quarter of a mile north of the tunnel exits going only about 400 feet, ending at a wall. There are two more short segments in Norwood, one under Section Avenue, the other under Harris Avenue near a ball field. Behind the baseball backstop at the park one can see surviving subway tunnel portals, similar to the ones on I-75, guarded by a chain link fence.

Once inside, we first noticed the smell: old, musty, much like the cellar of a very old house. It was much like walking through a massive cave: cold, gray, damp, and echoey. We could see our breath clearly in the 40 degree, below-ground temperature of the subway. There were no lights, no railings, no public restrooms and no vending machines; nothing to indicate that any time had passed since 1927. Aside from being very dirty, it almost resembled a perfectly preserved archeological site.

Since most of the downtown tunnels support Central Parkway, the City Engineering office continues to maintain them. The fallout shelter has been totally abandoned and is completely unusable. The subway tubes contain only the water main, still being used today, and fiber-optic cabling installed in 2000. Now, instead of passengers, the subway carries water and high-speed data.

During our tour we learned the truths about a couple of popular myths that surrounded the subway tunnels. Many people believe that rats and other rodents populate the subway. As we learned firsthand, there are no rats or any kinds of rodents because there is nothing for them to feed on. Also, some people think that there are entrances to the tunnels from access points besides those that exist above ground, such as through the basements of buildings along Central Parkway. That isn't true either; except for the aforementioned portals along I-75 and a few surface entrances along the streets, there are no other ways into the tunnels. There's also a rumor that one of the original subway designers killed himself, apparently because the tunnels didn't meet his suggested specifications. Thus, his ghost supposedly haunted the tunnels. Another story tells how ghosts of workers killed during construction populate the tunnels. But we didn't encounter any disembodied spirits during our trek or hear anything otherworldly. Also, no written verification of these rumors can be located.

The trip through the subway tunnels was a memorable one; afterwards we could fully appreciate what Cincinnati has lost. The tunnels are still there, the stations are still there, but the need for a subway is not. Unfortunately for the subway, Cincinnati's need for light rail or a subway continue to remain a dream into the new millenium.

This current map shows the present location of the subway tunnels downtown. (Courtesy City of Cincinnati.)

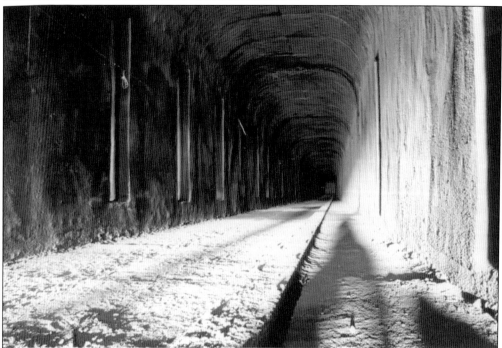

A subway tube in Norwood seems perfectly preserved. (Courtesy Greater Cincinnati Film Commission)

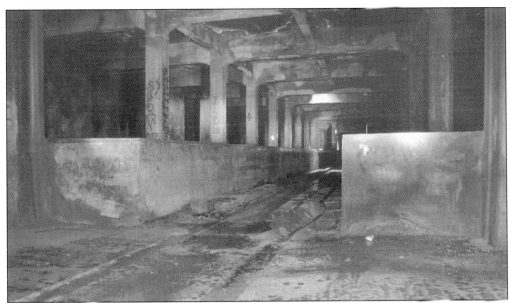

It was at least forty degrees in the subway, about as cold as the interior of a refrigerator. Race Street Station remains as a large concrete subway platform with graffiti painted on its many supports and walls. Huge pillars support the 14-foot high ceiling above. The floor is covered with a layer of dirt and dust. Just below the platform runs a set of parallel wooden stringers intended to support steel rails that would never be installed. (Photography by Suzanne Fleming.)

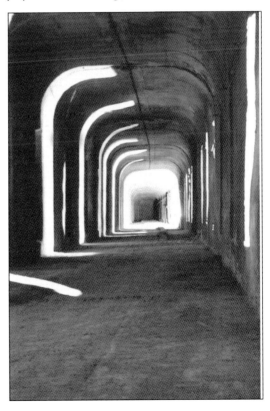

The long, lonely tunnel. (Photography by Suzanne Fleming.)

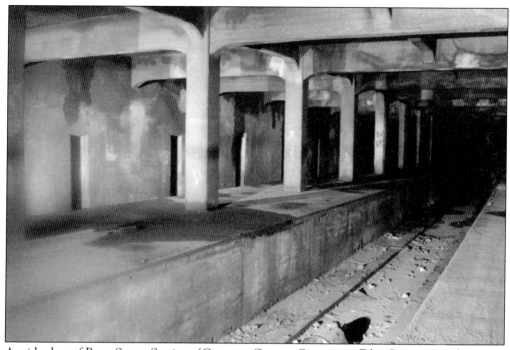

A wide shot of Race Street Station. (Courtesy Greater Cincinnati Film Commission.)

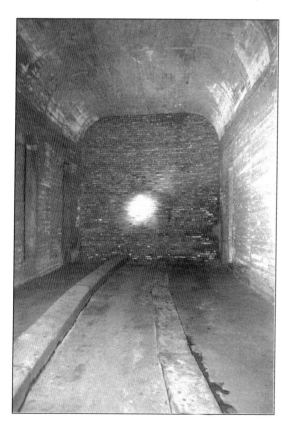

The tunnel ends at a brick wall at Walnut Street where the original construction crew finished working on this part of the subway nearly a century before. (Photography by Suzanne Fleming.)

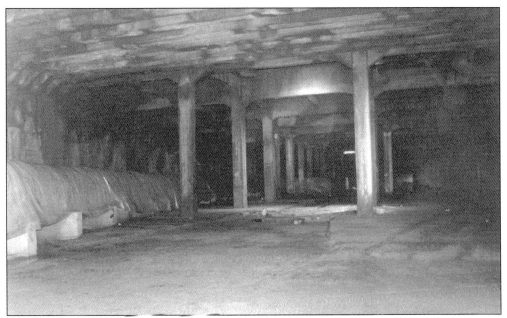

Along the south side of the station runs the water main; a tarpaulin covers its entire length to protect it from dirt and erosion. (Photography by Suzanne Fleming.)

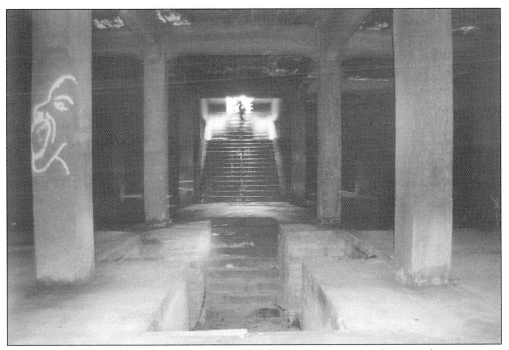

The station feels dismal and lonely, and truly abandoned by the city. Its design and construction makes one feel as if something could have really happened there. Race Street Station resembles a subway station with the lights turned off and everyone gone home for the day; built for a subway that never was, but it is still waiting for its time to come. (photography by Suzanne Fleming.)

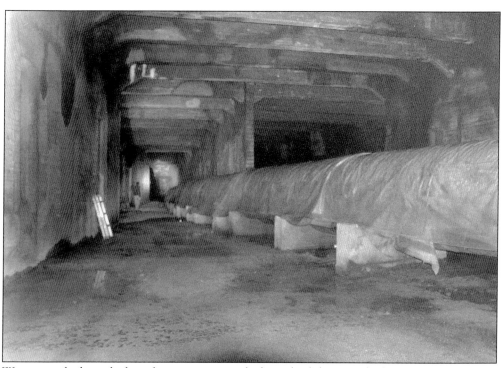

Water travels through the subway now, instead of people. (Photography by Suzanne Fleming.)

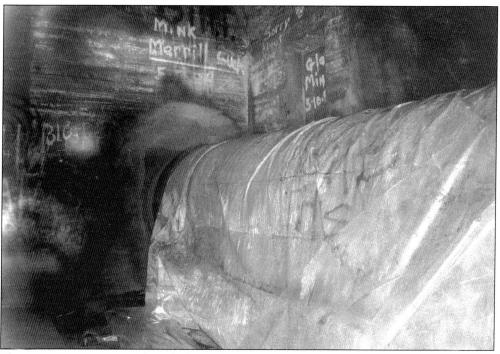

The water main continues through the wall of the subway. (Photography by Suzanne Fleming.)

Water has leaked into the subway; dripping from the ceiling, down the walls into massive puddles on the floor. Although the floor is concrete, decades of dirt have turned into mud, making for an unpleasant walk. Trash lay scattered in places, especially beneath the ceiling ventilators, but nothing can be scavenged from the 1920s. (Photography by Suzanne Fleming.)

Recesses are built into the walls intended both for ventilation for the subway train and to provide subway workers a place to stand in case a train were to blow by while they were working. In some places, stringers were laid in the floor at an angle off the main set of stringers to provide a siding to push subway cars off the main tracks. (Photography by Suzanne Fleming.)

The fallout shelter is surprisingly clean, mostly because the majority of the survival supplies had been removed in the late 1980s. The only things that remained were a couple of old barrels that once held sanitary supplies, but now hold trash. (Photography by Suzanne Fleming.)

To the right of the shelter are smaller rooms built for restrooms, bunkers, and an office. The office shows signs of earlier habitation, but is now a trash-littered room with exposed electrical panels. (Photography by Suzanne Fleming.)

The bathroom houses an extremely filthy shower stall, and scary-looking toilets in stalls without doors. The toilet bowls are filled with trash, and some toilet paper litters the floor. (Photography by Suzanne Fleming.)

Another room houses a couple sets of bunk beds, but these are the only survivors; the rest were removed years before. The walls were totally utilitarian, devoid of paint or decoration. (Photography by Suzanne Fleming.)

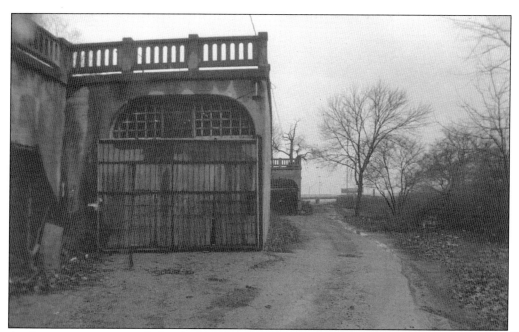

At the great concrete wall that borders I-75 are the large steel doors that cover the ends of the tunnels. Rapid transit trains would have emerged here from the subway to connect with the long-since demolished above-ground Marshall Street Station. The line would continue to the next short tunnel a quarter-mile north, then above ground to St. Bernard, east through Norwood, and in just a few minutes connect back to the loop on the eastern side of downtown. (Photography by Suzanne Fleming.)

The great wall next to the edge of Central Parkway. (Photography by Suzanne Fleming.)

A quick hike through the weeds next to I-75 will bring the explorer close to the north-bound tunnel. (Photography by Suzanne Fleming.)

One report calls this pedestrian bridge over Central Parkway the "Board of Rapid Transit Commissioners Bridge." Otherwise, this is known as the Baymiller Street Bridge, built at the same time as the subway. It reflects the architectural style of the subway. (Photography by Suzanne Fleming.)

The Brighton Bridge also reflects the architectural style seen inside the subway. (Photography by Suzanne Fleming.)

The Queen City in the late afternoon shadow. (Photography by Suzanne Fleming.)